♡ EAT WELL, DRINK OFTEN, ♡ AND BE MERRY... ♡

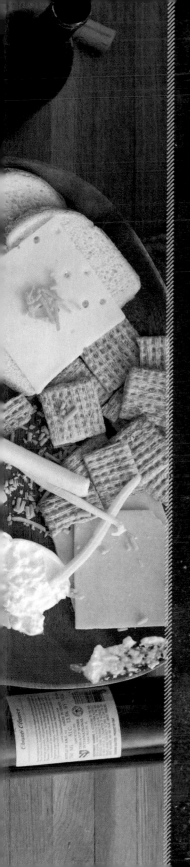

MY DRUNK KITCHEN

A Guide to Eating, Drinking & Going with Your Gut

Hannah Hart

itbooks
AN IMPRINT OF HARPERCOLLINS PUBLISHERS

Photography by Robin Roemer

Art direction/prop styling by Hannah Hart and Robin Roemer

HarperCollins books may be purchased for educational, business, or sales promotional use. For information please e-mail the Special Markets Department at SPsales@harpercollins.com.

FIRST EDITION

Designed by Shannon Plunkett

Library of Congress Cataloging-in-Publication Data has been applied for.

ISBN 978-0-06-229303-9

14 15 16 17 18 OV/RRD 10 9 8 7 6 5 4 3 2

To RECKLESS OPTIMISTS

AND ALL WHO BELIEVE
WE CAN DO MORE
AND BETTER

CONTENTS

PART 2

ADULTOLESCENCE
Savor the Cooking as Much as the Meal 45

PART 3

SO THIS IS LOVE

Recipes for Relationships 121

FOREWORD

BY JOHN GREEN

All the great food writers—from MFK Fisher to Julia Child—have understood that cooking and eating are not just about sustenance. We bring to our food all that is inside of us—the joy and the grief, and at times the intoxication—and the food is changed by the spirit in which we prepare it. I still remember the saddest peanut butter and jelly sandwich I ever made: I was twenty-two. My longtime girlfriend had dumped me. I had no career prospects and no money. I was living in a walk-in closet in a basement apartment in Chicago. A few days earlier, I'd reached for my box of Cheerios and the box jumped, because it contained a mouse.

I also remember the happiest PBJ of my life: Days after getting engaged, my now wife and I were in her apartment, drinking way too much wine, looking through her fridge for something we could make together.

Precisely the same ingredients resulted, of course, in vastly different sandwiches. The saddest PBJ superglued my tongue to the roof of my mouth with peanut butter, and the bread had all the flavor of construction paper. The happiest PBJ tasted like rainbows and roses. And this is the wonder of Hannah Hart's drunk kitchen: Whether you are deep in sadness or the happiest you've ever been, Hannah Hart knows how to make it better. She makes you feel less alone in the dark night of the soul, and even more joyful in the good times.

Hannah's YouTube channel rocketed to popularity not merely because she is punnily hilarious and knows how to make a fine drunken meal, but because like all the best food writers, in the process of teaching us how to cook she teaches us something about how to live. Hannah's fans are motivated by their love for her and for each other to raise money for charity and to volunteer in food kitchens around the world. We feel better about being ourselves because of her.

Food, when wielded properly, can make us more caring and generous. And no one understands this better than Hannah Hart. So yes, this book is hilarious, and you will enjoy every page of it. But make no mistake: Beneath it all lies the message that we must love ourselves and one another, and that together we can make it through.

INTRODU

You're a narcissist, right?

Good. Because this book is about you.

Well, it's really about me. But it's about me and you. So does that work the same way? I hope so, because this book is about self-improvement and maybe it can improve itself as it goes along. Has a cookbook ever been self-aware? If not, this may be one of the first occasions for it.

This book is also about self-preservation. Or self-preservatives. Or preservatives. Like jam. You think that a delicious jelly snack is ever crippled by self-doubt? Nope. And you shouldn't be either.

But defeating self-doubt isn't the only thing you'll learn in this catalog of delights! Here you will find out how to encourage your guests to get creative with their libations (Latke Shotkes, p. 17), how to achieve your goals with the resources at hand (Saltine Nachos, p. 53), and even the importance of communication during experimental bedroom escapades (Hot-Crossed Bunz, p. 158), but above all you will learn that it's in your best interest to be patient with your spouse during the holidays (Trifle Troubles, p. 189).

CTION

This book will open up your eyes to strengths within you and around you that you may have never seen. For example, have you ever really thought about the structural integrity of a sandwich?

You see, a sandwich has the ability to combine all these varying elements of life to manifest a singular creation. The sandwich is composed of many seemingly opposing parts. You've got the lettuce and tomato (which is the smarts), the cheese (which is the sexually arousing part), the butter (lube), and the bread (that's like our skin, it keeps our insides from ending up in a big sloppy mess on the floor . . . though if your sandwich is already on the floor, then you should probably eat that. Like right now. That's the safest thing that you can do. Too much time has passed already to think about making another. Everyone is looking. Wait. Okay go now.). A sandwich comes into being and exists with you without judgment. Its presence in your life is only to coat the stomach lining of your soul so that the harsh spices of reality don't make your heart burn. And we musn't judge each other's sandwiches. Or anything that we create. And frankly, as long as the sandwich of my life isn't fucking your wife or punching you in the face, I think that you've got nothing bad to say about the things that I do. (P.S. If I've done either of those things, then consider this my formal apology, Tim. I mean, nobody.)

So, as is clearly stated with my flawless sandwich analogy, this book is going to show you a different way of looking at things. Cookbooks especially.

And ultimately, my goal is that by the end of reading this book you will have learned a thing or two about how to follow your heart.

But first you'll have to trust your gut.

LOVE,

KITCHEN BASICS

How to Make the Most of What You've Got

Life is not a box of chocolates.
Life is more like an empty plate.

That's not to imply that your plate is and forever will be bare, but rather that the emptiness of the plate mirrors the blank expanse of an unused canvas and the ingredients (or paints) we begin with are predetermined: ethnicity, location, financial status, genetic predisposition to chocoholism, etc.

Now, all of these factors differ from person to person, but the shared experience lies in the random lot you are dealt . . . and that it is up to you (as it is to all of us) to fill your plate with a meal you'd like to eat. As Voltaire once said, "Each player must accept the cards dealt: but once they are in hand, he or she alone must decide how to play the game." Or something like that. I don't remember exactly . . . I'm not very good at remembering quotes word for word, or following instructions step by step, or staying on track when writing the fourth paragraph of my first book . . .

Anyway! The first step in creating the meal of your life is to properly assess the fixings around you. Like stumbling into a kitchen (perhaps while drunk?) and spying a loaf of bread, some butter, some cheese, and knowing *deep in your core* what to do next.

For me, this began as a child. Without going into too much detail, I will simply say that my family struggled with money and I spent a great deal of time alone. Now, despite the disadvantages of my home life, I was blessed enough to never be bullied. I was well liked and friendly and frankly just loved being in the company of other kids. So for the most part, I never felt "different"—except during lunch.

During lunch, there was no simple way to hide the truths that food revealed. Everyone would sit on the asphalt in circles, or at the lunch table in rows, and in front of each child would be their social marker:

- **Brown paper bag labeled with name, simple sandwich, nothing more:** You could tell that this kid had a single parent who was trying. They probably knew some Tracy Chapman songs by heart. On Halloween their costume (if any) would be homemade.
- **A balanced meal in a plastic lunch box with thermos:** This meant that there was at least one doting parent at home while the other was off earning their station. That kid occasionally showed up with something store-bought—an item a parent could grab while standing in line for their coffee. Maybe this meant the night before (or the morning of) had been a little rough on the home front.
- **Hot lunch:** The contents were the same for everyone, but some paid with money and some had special tickets. I would sometimes start the year with a special ticket, but if there was ever a renewal period, that's when my portion would run out and I'd be left to my own devices.

Thus, relying on the special ticket for making sure I got fed at school was a faulty system. "Will She Eat It?," however, was not.

I like to think of "Will She Eat It?," as an interactive performance piece: an art form to be executed with extreme attention to detail and a subtle grace. If undertaken lightly, you might fall into the unpleasant category of "mooch," from which there would be no return. My older sister had made this mistake, and I was fortunate

enough to witness this play out in the politics of her fifth-grade social circle from my second-grade sidelines.

The rules of the game were quite simple. Everyone would contribute a portion of their lunch and *as a group* we concocted a special recipe. Upon its completion, I would . . . eat it. Combinations could include (but were not limited to):

- M&M's and Fig Newtons, maybe with an accompanying ketchup garnish;
- Cheez-Its dipped in chocolate pudding;
- Potato chips crushed into Jell-O snacks (preferably green-flavored for the limey kick; the reds didn't do much for my palate and would cause headaches from what would later be identified as a familial allergy to the popular chemical Red Dye #40, outlawed in many European countries but readily embraced by our American dietary needs for color and excess);
- Bologna and peanuts.

The point of the game was to encourage as much chaos as possible. Given the diverse social circles on the schoolyard, it was easy to bounce from group to group without drawing too much attention. I was lucky in that way. I liked to think of myself as something akin to a traveling minstrel. With an appetite.

The game moved in easy cycles, as it was a community effort, really. Bursts of laughter would attract others. It brought people together and kept everyone involved. I considered using this as a future campaign slogan for office:

"Yes, I'll eat that."

With everyone's lunches laid bare, we could observe each other's differences and expand our tiny worlds.

"Why does your juice box look like that?"

"My mom always makes me eat leftovers."

"What's wrong with your Cheerios?"

"These are Froot Loops."

"No, those are Fruity O's. I have Froot Loops."

"OH! LUCKY! I want Lunchables."

Ah, Lunchables.

Fucking delicious, amazing, perfect Lunchables. Food that was so clean it couldn't even touch *itself*. Endless combinations and assemblies. Stacks of snacks to satiate. Nothing on this earth could beat the taste of that sweet plastic cheese and the hot-pink meat. On top of a Ritz cracker? This was the height of luxury in my eyes. My lunchtime Lolita. The second someone peeled back that plastic top, the longing on my face could belie the levity of the game itself. The sheer want would radiate from me.

(Not to mention that Lunchables kids were their own breed in my mind. They were on sports teams, they seemed to be endlessly tall and slender, and they always had siblings. Lunchables parents knew how to get a family of six out the door. That sort of family often had a student body president or two in the mix.)

But let's go back to life as an empty plate. Each day we must fill it. But we won't always have the pantry full of whatever we like best (for me that would be a pantry where every shelf contained cheese, the bottom shelf bearing the most soft and subtle, then each level above graduating to firmer and . . . stinkier, frankly), but that doesn't take away our agency over what's available.

In the section ahead, KITCHEN BASICS, you'll learn the foundation of kitchen improvisation. You'll learn how to say "Yes!" to your instincts and put that positive spin on the mess that's unfolding around you. Now, don't worry, no one begins as a master of self-sustainability. Each of these recipes will come with additional tools and tips (and drinks) for filling your heart as well as your stomach.

Take this bacon, for instance . . .

This bacon is an optimist! Somebody's doing it right! (As long as "it" doesn't refer to properly cooking bacon, because I mean come on.)

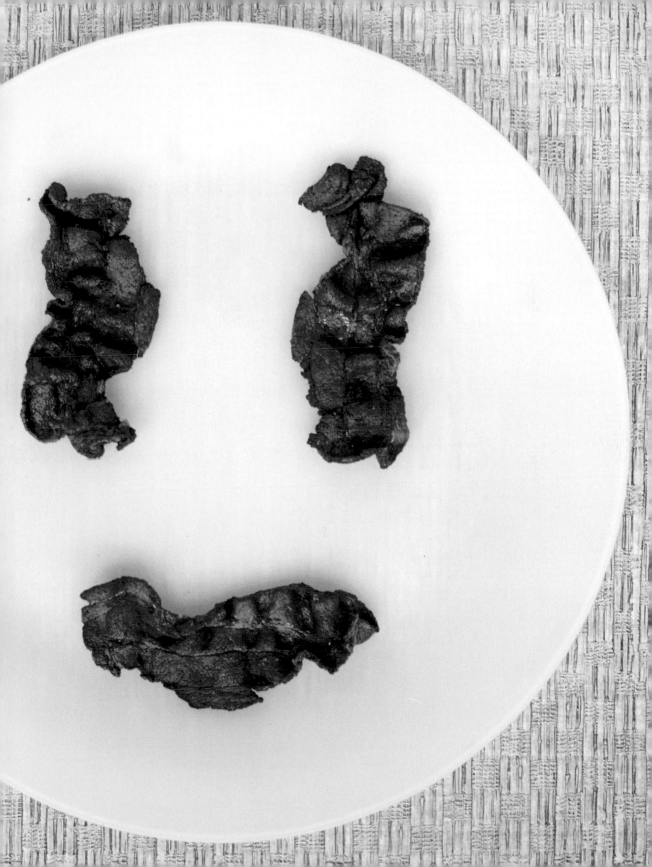

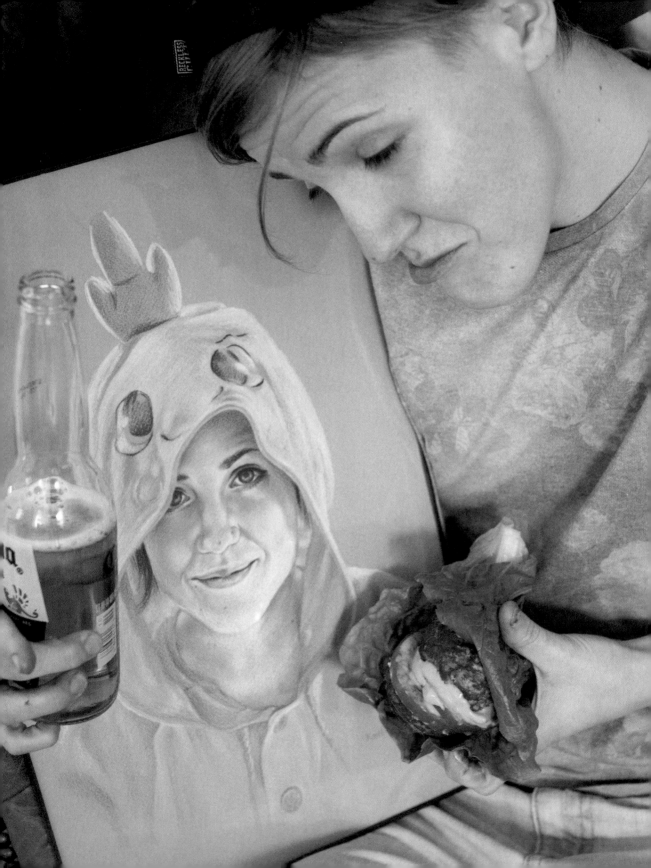

{ THE HARTWICH }

If you don't know history,
then you don't know anything.
You are a leaf that doesn't know
it is part of a tree.

—MICHAEL CRICHTON

I'd like to start this book of original recipes by saying that nothing is ever really original. Not to imply that this whole thing has been plagiarized (shout-out to Shia LaBeouf!), but rather that invention stems from the ability to connect information to imagination.

Thus, it's important to use history to learn about things. It helps you expand your perception of the known world and increases your ability to create and connect within it.

For instance, the origin story of the sandwich has always been one of my favorite momento in history.

The 4th Earl of Sandwich, John Montagu, was a gambler and a chatterbox. He was also a brilliant military strategist and possibly a workaholic. Whatever. The point is that he was constantly occupied with doing shit. Thus, never wanting to break from the task at hand (which was primarily drinking and gambling), he would simply order his kitchens to bring him a slab of meat wedged between two pieces of bread for ease of consumption. This habit became well known among his associates, so they too began to order "The Sandwich" when in his company.

So see! The best of inventions can come from tales of inebriated convenience. I call this delectable treat The Hartwich, because I am self-absorbed.

> **PRO TIP:** To learn more about things, read books or use the Internet!

Cocktail

Casual beer. Appropriate for solo day-drinking!

Ingredients

* bread crumbs
* ground turkey
* garlic
* oregano, basil
* avocado

* hummus
* bean sprouts
* tomato
* raw onion
* cheese
* lettuce

* potato chips and dried seaweed (for snacking on)

Instructions

First, mash the bread crumbs and the ground turkey (or chicken, depending on your mood and what is in your fridge) into a giant meatball, roughly the size of your first. Throw in some garlic or whatever to give the meatwad an extra punch. I like to add a little oregano, basil, or that "Italian seasoning" mix that the spice company so helpfully puts together for me.

Then, bake it. Cook it until it is done, all the way through. Don't let the Hartwich poison you.

Once you've got your giant baked meatball, cut it in half so it roughly resembles the top and bottom of a hamburger bun. (AHA, now you see where I am going with this.)

Next, mash up your avocado and use it as a spread on your buns (not those buns, people), along with the hummus. Throw in bean sprouts, tomato, and onion. Take a break and eat some seaweed or potato chips as a snack. Add some cheese to the sandwich if you do the dairy thing.

Use two pieces of lettuce to hold your sandwich and take a bite.

The sandwich should be roughly the size of a small slider, and pretty easy to consume. Make like five. Eat them in private for maximum enjoyment.

WARNING: Cooking in an oven, on a stove top, or on any heated surface (including city sidewalks in summertime) should only be attempted while accompanied by an adult. And by "adult" I mean someone who isn't drunk. It can be your kid sister too. She seems pretty responsible for a sixteen-year-old. I mean, she's always reading those YA books, so she must have learned a thing or two about life.

Life Lesson

Sometimes when I have an original idea, I like to keep it to myself for a while. Giving away the goods or sharing the thought before it's fully cooked can sometimes reduce your enthusiasm level or incentive to execute the as-of-yet-unveiled brilliance. It's okay to keep things close to your chest and not share them until you're ready to do so. Thus, feel free to take those improv classes without telling your coworkers. They might not get it for a while and, for me, disbelief does not translate to motivation.

Don't do things to prove others wrong. Do things to prove yourself right.

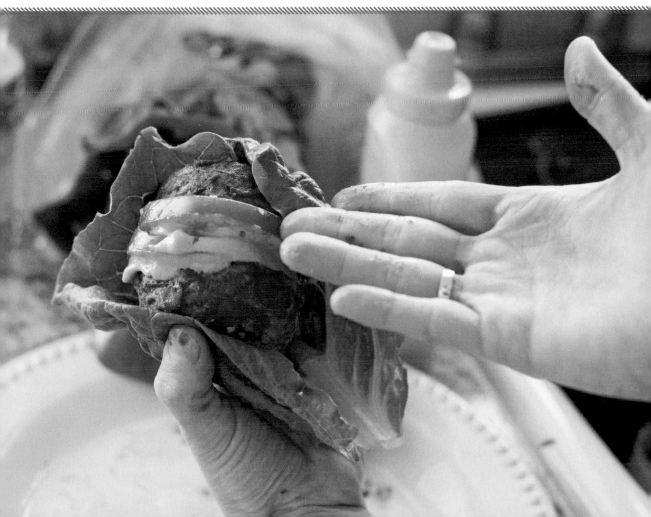

{ CAN BAKE }

Life is to be lived, not controlled; and humanity is won by continuing to play in face of certain defeat.

—RALPH ELLISON

Now, to be fair, it's not easy to create an original piece of art from scratch. For instance, The Hartwich took *at least* an hour for me to think of and some people just don't got time for that sort of dilly-dallying. So! If you want to create, but are hindered by the weight of the task ahead, then here is a recipe that will still allow you some small measure of invention . . . but mostly it just involves heating things that are already prepared in a can.

Cocktail

Beer (in a can! because this is the theme?)

Ingredients

* a can!
* something to put on top of the can!

Instructions

First, go to your cabinets and check out what you've got. If you find you've got an abundance of canned items that you never get around to opening, this might be a good time to send in that *Hoarders* audition tape that everyone keeps joking about. Ooh! Or you could donate some of those cans to your local food bank. Putting the "CAN" in "PHIL-CAN-THROPY". . . What do you mean that's not a word?

Next, open up the can. Then put something on top. Need suggestions?

- Tomato soup > a grilled cheese
- French onion soup > Swiss
- Chili > an entire baked potato
- Chicken soup > puff pastry (pictured on page 13). Chicken NOT pie!
- Cherry pie filling > puff pastry again! Instant pie.
- Black beans > cheddar cheese and tortilla chips!
 Weird, hot, bland nachos!

See, the options are really limitless. The world is your oyster. Ooh! Oyster crackers would be good with a can of clam chowder. Better add that to the list. Feel free to write it yourself in pen. Here, let's make a space for your own genius below.

- _____ > _____ (That's great!)
- _____ > _____ (Yum! I want some!)
- _____ > _____ (You are so smart and good!)

I thought I would throw in some affirmations just in case. Now delicately place the item on top of the can and the can onto the top of the top rack of the oven. Close the door and never look back!

Except in like ten minutes when you definitely should look back and take it out of the oven.

Life Lesson

Don't tell yourself to quit before you ever get the chance to try. Never forget the importance of a CAN-DO attitude.

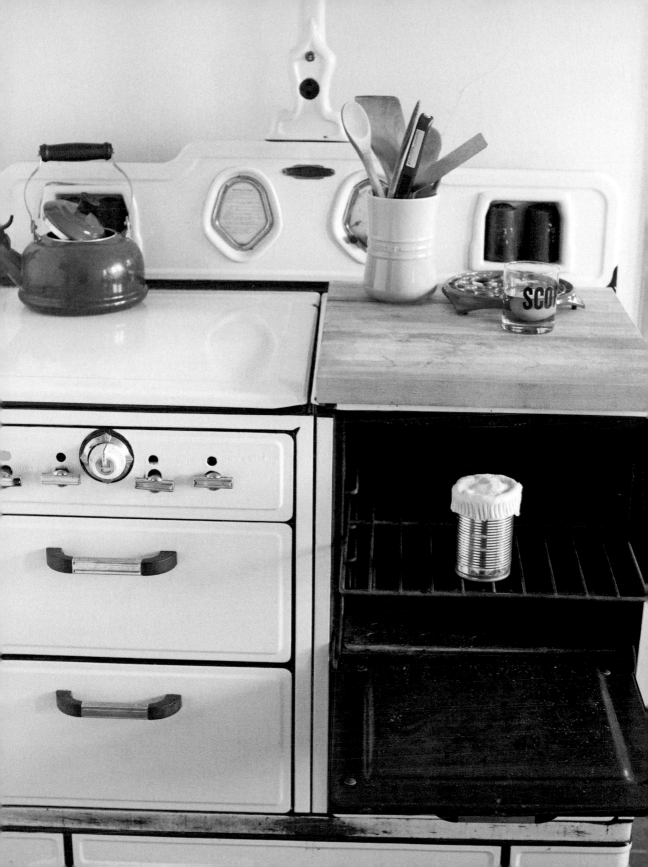

I sometimes have a hard time explaining what *My Drunk Kitchen* is all about. Or why it matters to me so much. So I went on my Tumblr and asked people what it meant to them. This is what they wrote:

"*My Drunk Kitchen* isn't just a show. It's a wondrous virtual community of love, learning, and acceptance. And puns. A shit ton of puns."

—pippinmiller

"*My Drunk Kitchen* is a few minutes where you can laugh at puns and slurs and slips and drops and learn absolutely nothing."

—bestofthorn

"*My Drunk Kitchen* is about realizing that just because something didn't turn out the way you wanted it doesn't mean it is bad, that you can make the best out of a bad situation even if it seems hard to try, and to never forget cheese when making grilled cheese."

—the-frozen-city

"It's a show that is about loving and accepting yourself. It is about making the best out of an interesting situation. Sure, there is drinking, messes, and puns, but above all, *My Drunk Kitchen* is a show that shows you that you are not alone and reminds people that there is more to life than just you."

—weirdo-in-austin

"*My Drunk Kitchen* is about making the most of every situation. Like maybe everything didn't turn out the way you expected it to, but there are always lessons to be learned and silver linings. It's also about loving yourself and loving others. And having a good time. It's like one giant international party facilitated through the Internet. It allows people from one side of the world to have a good laugh with people on the other side. It's about so much. :)"

—thoughts-to-constellations

> **"This is a show about friendship."**
> —My Drunk Kitchen, episode 1, March 2011

> " *My Drunk Kitchen* is an excellent example of the journey being more important than the destination."
> —Lucy8675309

So basically, the timeline breaks down like this:

In March 2011, I was lonely and got really drunk and put it on the Internet.

In March 2012, I moved to Los Angeles to pursue a career in entertainment.

In March 2013, my roommate and I launched a campaign to raise over $200,000 and travel across the country doing charity work culminating in over 100,000 pounds of food being redistributed and over 94,000 people fed.

And now in 2014, I am "publishing" my first book.

If you can figure out how that happened, let me know. For now I am just grateful that so many people around me allowed this to happen. So thank you.

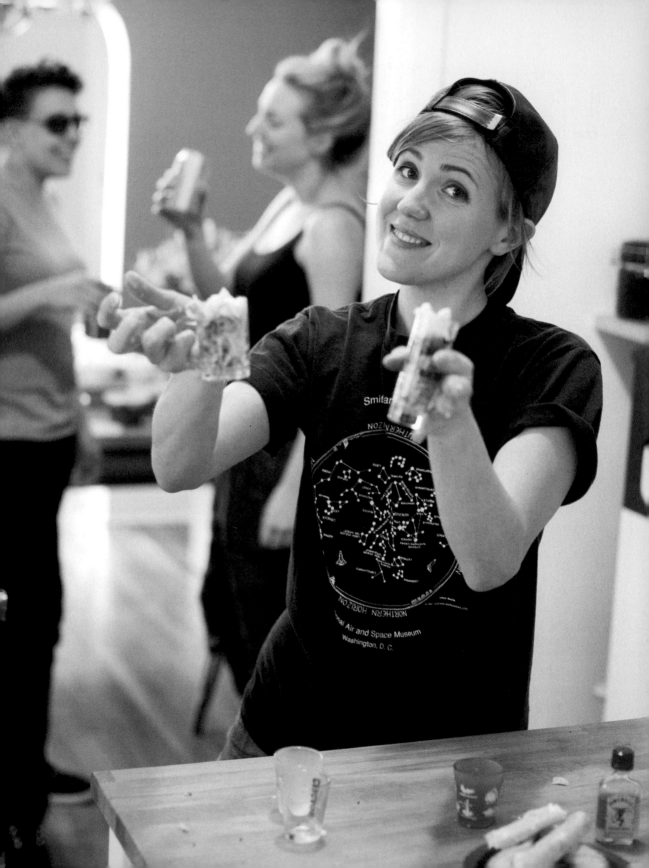

{ LATKE SHOTKES }

One more drink and I'll be under the host.

—MAE WEST . . . OR MAYBE
DOROTHY PARKER . . .

In the same way that the Can Bake allows you to create without the intimidation of starting from scratch, a couple of Latke Shotkes allow you to take a shot or two without the defeat of later blacking out.

See, the "chaser" is simply intended as an analgesic to the aftermath of shot-taking.

 PRO TIP: Common chasers include citrus, soda, beer, kisses, etc.

But . . . what if the chaser to a shot was actually intended to help with the night of drinking ahead?

Now, as we all know, potatoes are an excellent coating for the tummy before/after/during any night on the town. Thus, I'd like to present to you the genius behind a starch-based accompaniment to any form of drinking.

Cocktail

Let's just say you're taking a shot of vodka because this recipe is potato themed.

Ingredients

* A latke! (Or just use hash browns. Actually, frozen Tater Tots would work great for this. Plus that's just way easier and it involves less danger.)

Instructions

Heat your oven and bake your browns. Once they're cooked, squish them into shot glasses. Find some tiny spoons. If you don't have any, then sprint to your local ice cream store and ask for a sample of every flavor. Save those sample spoons. Get home and deny to everyone that you in fact licked all of the spoons you are handing them. Force them to take shots and stop asking questions. Then bring them some warm potato mush with a dollop of sour cream on top. Drink up and dig in!

Life Lesson

Always have tiny plastic spoons.

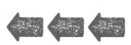

You'll be amazed at how often you use them. Also, if you know what usually happens when you act a certain way (ex.: taking too many shots without eating), then you can prepare better in the beginning to avoid that reoccurring consequence. Plan before you puke!

ITEMS EVERY KITCHEN MUST HAVE

- ketchup
- mustard (more mustard than ketchup though— always running out of ketchup)
- frozen Tater Tots

- copious amounts of cheese
- bread
- a happy hearth
- patience
- passion (for something— for anything)

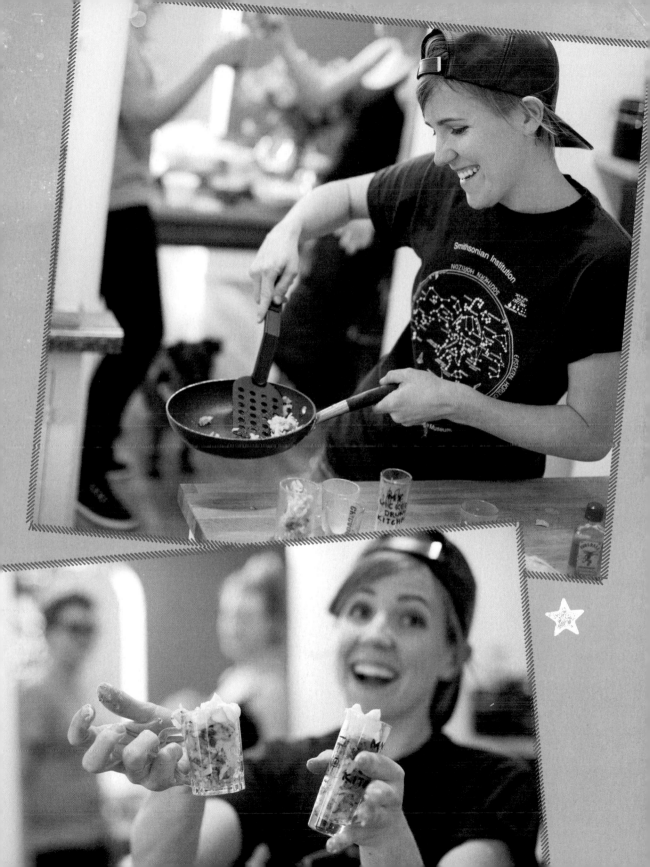

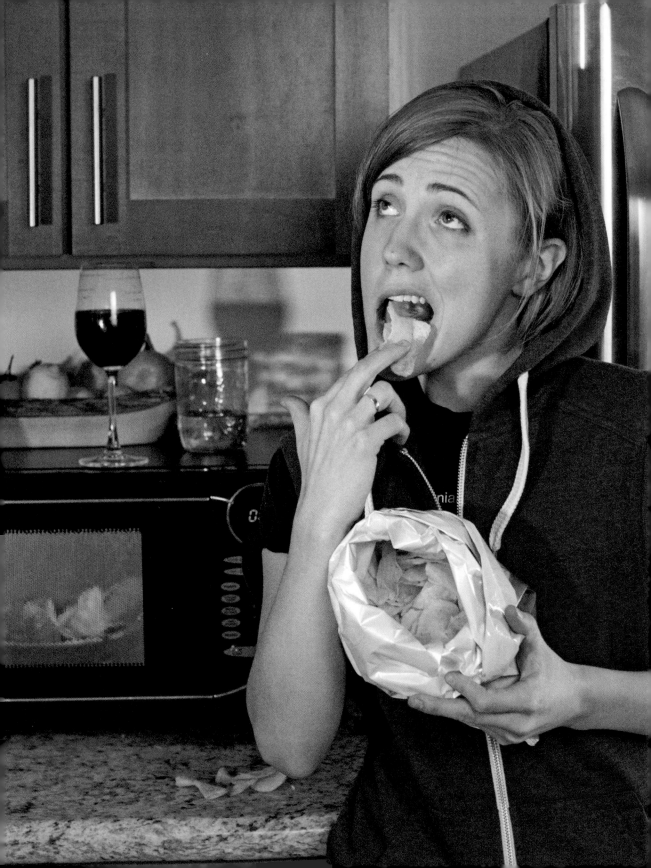

{ LAYZAGNA }

You gotta know when to be lazy.
Done correctly, it's an art form that
benefits everyone.

—NICHOLAS SPARKS

We are really getting somewhere now! But let's rest in our efforts for a moment and see if anything we've learned thus far has been ingrained in our minds. It's good to take a break from learning because it gives your brain room to process. Also, never doubt the importance of a lazy day.

Actually, that reminds me of an excellent idea that first came to me when I was eating a bag of potato chips while waiting for some lasagna to reheat. Upon taking it out of the microwave, I thought: "Man, I really don't want to stop eating these chips."

> **PRO TIP:** It's always good to be eating while you're making something to eat so that way you don't eat it all if you're supposed to be sharing.

Cocktail

Chianti!

Ingredients

* microwave-friendly frozen (or leftover) lasagna
* 1 bag potato chips

Instructions

Reheat lasagna (or cook it according to the package instructions). Using your fingers, peel back a layer of the lasagna. Ow. Okay, use a different finger. Ow. Okay, still hot. Just maybe use a fork. Ugh, but you don't have any clean forks! Wait, then what were you thinking making lasagna in the first place? How are you supposed to eat that with no fork whatsoever? I mean, I'll give you points for being proactive about attaining food, but the level of foresight (FORK-SIGHT?) leaves much to be desired . . .

So, the next step is to go ahead and wash a fork. Ugh. But the forks are at the *bottom* of the dirty sink pile. There are just so many . . . and nobody has washed a single one. And since when is it your responsibility to wash ALL these dishes anyway? Maybe since you started living on your own? Huh. Maybe the dishes *were* always done by your roommate in your old apartment . . . she did always complain that she did all the cleaning . . . but it wasn't always only her mess.

Yikes. Does that make you a big asshole? Better do all these dishes right now to retroactively atone for your sins. Also, this floor could be mopped some. Better do that right now too.

Great! At this point your lasagna should be cool enough for eating! Go ahead and peel it back and insert select potato chips. Sit on your newly cleaned floor and enjoy! Yum!

Life Lesson

If you find yourself always waiting for the things you want, then you might want to just start taking care of the things you need.

Quick Word from the Author: Hello!

Quick Comment from the Author: Microwaves are scary, right? I can't be the only person who thinks this . . . If you agree, leave a comment in the comments below! Oh wait, this is a book, not a YouTube video . . .

KITCHEN ESSENTIAL: The Perfect Mimosa

Pictured below are the only ingredients* you will need to make The Perfect Mimosa.

The first step is to pour out one shot's worth of champagne . . . but be careful when opening . . . and when pouring.

Next, take that shot of champ like a champ and pour orange juice in the now empty shot glass. Then pour that shot back into the champagne bottle. Simple and sweet and ready to serve.

People have a tendency to overcomplicate things. Sometimes it's best not to mess around too much and just get straight to the good stuff. Sort of like watching clips of your favorite scenes from *Arrested Development* on YouTube. I love me a good montage in the morning.

* Except for the orange, that's just there to look classy. Actually, I think that's a Satsuma? Which is a mandarin orange. I think that means it's still an orange? Why call it something different? Hey, now that I think about it . . . what the hell is a tangerine anyway? Googling. Oh, it's closely related to the mandarin orange. WHY ARE THEY CALLED DIFFERENT THINGS THEN? Ugh, I wish I had never known that. Now it's going to bother me. Sometimes the Information age can be a real letdown.

{ COMPOUND BUTTERS! (COOKING WITH INMATES!) }

But have you guys even watched *Orange Is the New Black* yet? It's just SO GOOD.

—HANNAH HART, every day of fall 2013

At this stage of our cooking adventure, you may be wondering if I'm ever going to teach you some small addition that can be incorporated into many meals. Like a fancy type of sauce that will go with different dishes or something.

Well . . . um . . . here is my best attempt at that.

But first I have a question FOR YOU (bet you didn't see that one coming)!

Are there cooking programs in prison? Because I think that making different types of something . . . perhaps butter . . . would be a good activity for inmates. Seems smart. Low risk of injury or exposure to lethal weapons. Aside from cholesterol, maybe?

Cocktail

Hooch made from somewhere! (Apparently people can make moonshine in prison? Or at least they can on TV?)

Ingredients

WHAT DO YOU CALL IT WHEN YOU DRINK PRISON HOOCH OUT OF A COFFEE CUP?

A MUG SHOT.

* tons of buttah
* tons of various herbs and spices
 (see my choices in the instructions on page 26)
* a device for compounding
* whatever else you want to mix in

Instructions

Cut the butter into cubes using a non-sharp object that you couldn't possibly shank somebody with. Then wait for it to get to room temperature and maybe talk to your fellow inmate about how their rehabilitative therapy is going. After that winding road of conversation, go ahead and mix your butter with the herbs and spices you've been allowed.

Life Lesson

Now, I personally don't find cooking to be relaxing and/or therapeutic. But I do think that mashing things together could probably help work out some aggression. Might even open some doors for time on the outside! Could be your new . . . dare I say it . . . bread and butter?*

* AUTHOR APOLOGY: I'm sorry for that last one.

WARNING: Don't ever, EVER use a sharp knife when drunk-cooking. A butter knife should be more than enough. It serves as an excellent indicator of what you should/should not be attempting to cook. For instance, you know what a butter knife can't cut through? RAW STEAK. So maybe you shouldn't be trying to cook meat products. (Or if you do feel like trying your hand at meat, see Pansteak, page 191.)

{ FRUIT COCKTAIL }

SIKE FRUIT COCKTAILS ARE DISGUSTING

Guys. Cantaloupes can contain salmonella. Best to avoid them at all costs. Let's just move on.
(This page does not include photography out of respect for your taste buds.)

Life Lesson

Sometimes reading *Scientific American* can leave you scarred for life.

IMPORTANT KITCHEN TERMS

OW! — Slow down and pay more attention.

Oh . . . no . . . — Call emergency services.

Shit. — Seriously. Call someone for help.

Shit! — You missed a step in the directions . . . but no big deal.

It'll be fiiiine — It won't be fine.

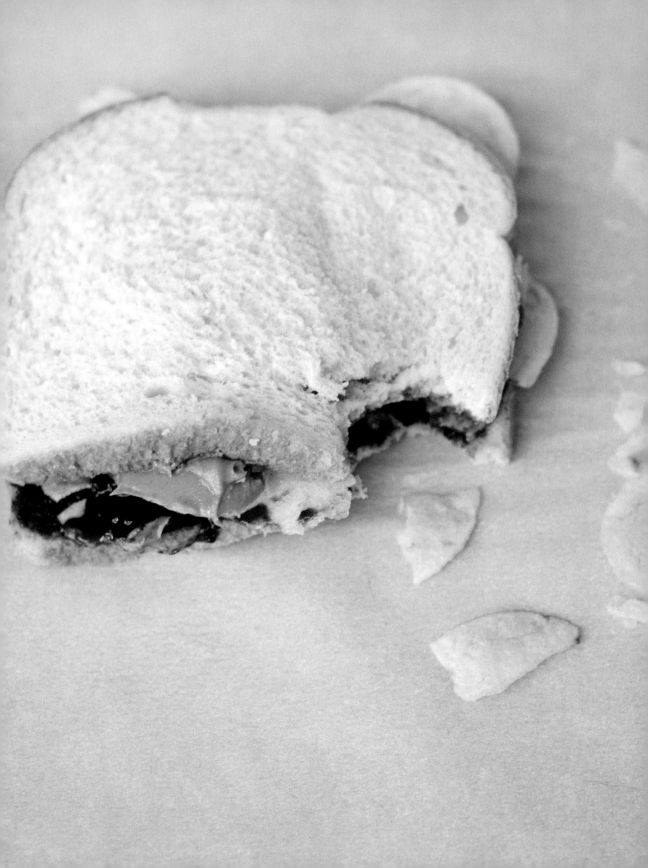

{ PB&J&PC }

(PEANUT BUTTER & JELLY & POTATO CHIPS)

Put potato chips on a sandwich!

—LIZ LEMON

Speaking of *Scientific American!*

It has been *scientifically proven* that you can put potato chips into any dish to improve the meal. You see, by making things crunchy you stimulate more parts of the brain with the om-nom-nom-crunch-crunch sound. Also, peanut butter is a good source of protein. And jelly is a good source of tasty-sweet that blends nicely with the salt. And the aforementioned crunching helps you become more awake while you're eating. That makes this a good meal for breakfast.

Trust me. It's science. That's how science works. It's based on trust.

Cocktail

Blueberry vodka-tini with a peanut butter rim rolled in crushed potato chips.

Ingredients

* . . . really?

Instructions

First step! Save book ink by skipping unnecessary ingredients portion of recipe. Next, take your two slices of bread and put them in the toaster. If you have a toaster setting option, it's best to set it to 1 or 2 for perfect warm-to-soft-to-crisp bread ratio. It's important not to have your bread too toasted because it

will detract from the potato chips. But you'll still want your bread warm and firm. That's what she said.

From there, allocate your personally preferred portion of peanut butter. Heap on the jelly. Next, put a bunch of potato chips inside and take a bite. Now, tell me that's not good.

Life Lesson

Sometimes simple additions to a standard something can make it oh-so-new!

PRO TIP: To make extra money in college I participated in a series of case studies for cash. It was a great way to earn an extra buck! Just don't fall for any guy at a party telling you he's studying anatomy in his bedroom later. Be like, "Oh wow that's cool byeeeeeeeee."

But then if he ends up being a famous anatom . . . y . . . ist (?), see if that study is still an option. He probably can pay you better now anyway.

{ THINGS IN A BLANKET }

Failure is the condiment that gives success its flavor.

—TRUMAN CAPOTE

Remember that time we created a brand-new use for canned soups and things? It was like . . . four pages ago? Well, that got me thinking. All those cans looked exactly the same when you took the wrapper off . . . and while I could have thought about how that's a metaphor for human beings in relation to each other . . . my brain went off on a different tangent instead.

See, I don't think that society praises creativity enough. I think we are focused on generating the maximum output possible, making the most money possible, reaching the most people possible. That's why when things are made in a factory they all come out looking the same. Uniformity makes the machine move faster.

That may be the way mass production is run, but there's no reason to let that mindless monotony into your home.

So, what's a great way to test your own capacity to create? Well, try a new spin on Pigs in a Blanket. All you really need is some crescent rolls and a pinch of enthusiasm.

Cocktail

If you're making something savory: Chardonnay.
If you're making something sweet: Riesling.
Or switch those. Whatever.

Ingredients

* some crescent rolls
* a pinch of enthusiasm

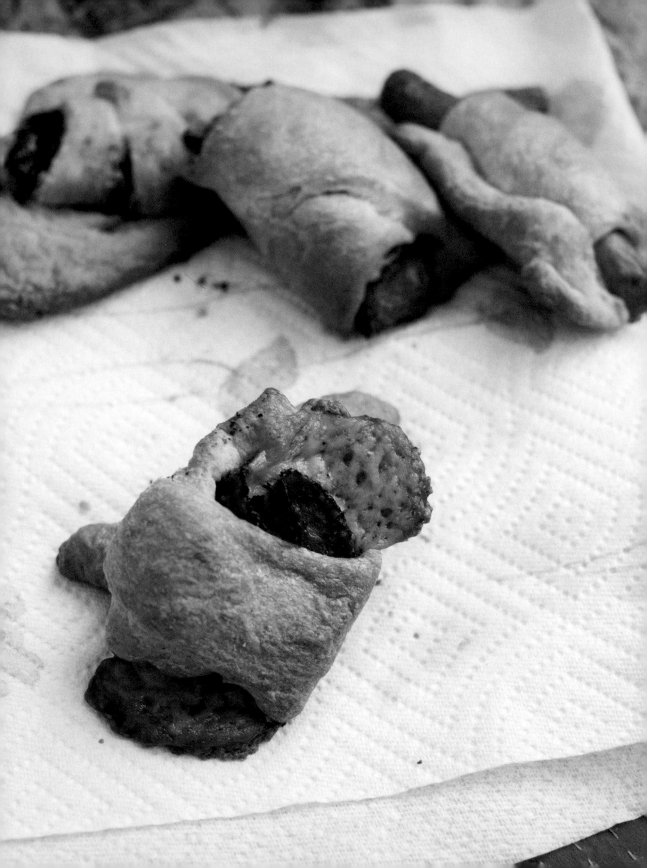

Instructions

The first step is kind of the best part of this whole recipe—opening the crescent rolls! It's so fun! Look at how cute the little tube is and then it makes a popping sound and poof! Rolls that are fun to touch and play with. You can also put fortunes in them. (SPOILER ALERT: Fortune Rolls, page 99.)

Next, open yourself to possibility without judgment: Jam? Sure. Chutney? Why the hell not. Mustard and ketchup? Probably going to need to put a little meat into that too. Ooh! Good thing you have hot dogs! Blammo.

Once you're satisfied with your findings, place into the oven and let the magic happen.

Life Lesson

Accept failure.
Not all of your creations
are going to be good.

In fact, some of them might be downright disgusting . . . but that's the creative process, isn't it? I would say you get double the amount of failed ideas before finally stumbling onto something that's *good*. And for Things in a Blanket, what could that good thing be?

Well, I will tell you: **Put Nutella in that f——in' blanket.** Then bake it. It's basically just an orgasm for the ol' mouth-parts.

My Favorite Thing to Keep in the Bar

Tiny airplane bottles of Fireball. It's a cinnamon whiskey that always leads to memories. It's delightful and sweet and spicy and just enough liquor to wake you up and keep you going. Also, if there is someone at your party who "doesn't like to drink," just hand them some and say, "This is mouthwash that you can drink."

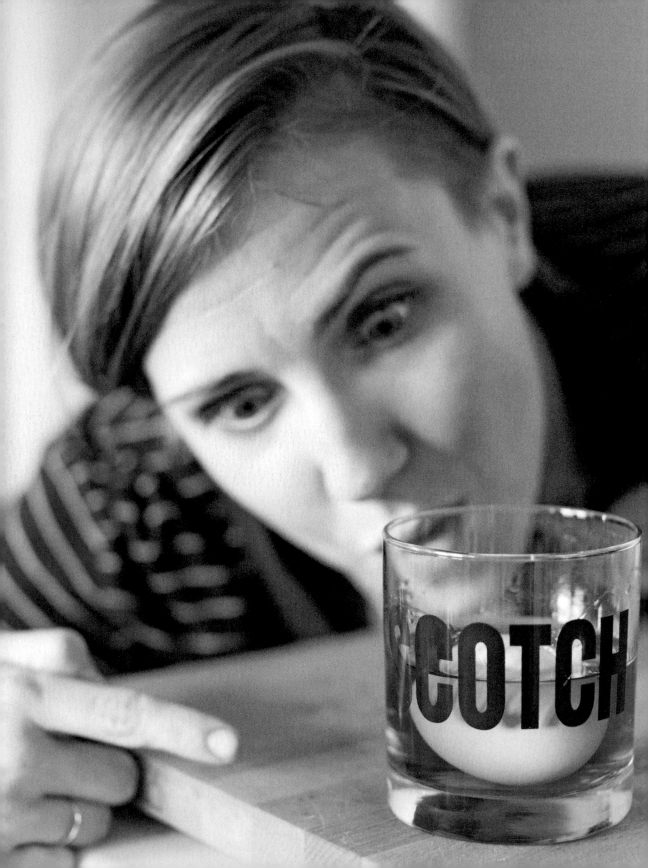

{ SCOTCH EGG }

Simplicity is the ultimate sophistication.

—LEONARDO DA VINCI

I couldn't help myself.

Cocktail

Scotch.

Ingredients

* egg

Instructions

The only step is to know what a Scotch egg is so that this makes sense.

WHAT YOUR WINE STOPPER SAYS ABOUT YOU

- **Top Hat:** You're a fun-loving kind of guy. But you know how to keep it classy.
- **Lil' Dude:** You enjoy a tiny companion or two while you indulge.
- **Monogram:** You like to leave your mark. You also steal pills from your friends' medicine cabinets. Probably.

Life Lesson

Puns are important. This is an amazing visual pun.

And on that note we come to the end of the first part of this book. At this point you've learned some amazing tools to keep your kitchen cookin'! To recap, we've covered how to make:

- **The Hartwich**
 (Knowledge is ingenuity! Learn from the past!)
- **Can Bake**
 (Inventing things is hard! You don't have to start from scratch!)
- **Latke Shotkes**
 (Plan ahead to avoid a night of dread!)
- **Layzagna**
 (Take time to attend to your personal needs . . . like occasional lethargy!)
- **Compound Butters**
 (But seriously, *Orange* is one of the best shows on Netflix.)
- **Fruit Cocktail**
 (NO.)
- **PB&J&PC**
 (Simple additions can bear great results!)
- **Things in a Blanket**
 (You may know what you're doing, but try to think outside the blanket!)
- **Scotch Egg**
 (PUNZ4LYFE)

And that's great! But this is also a book about *drinking,* so I would like to take a moment to explain to you some warnings—a small caveat or two—before we continue. As I said earlier, knowledge is power, so before you go to a party and play power hour (that game where you take shots of beer every minute? yikes), here are some things that you should know about that good ol' firewater that we call "DRANK."

10 Things ~~Alcohol~~ ^Alcohol Does to Your Body

(After all this time, I still spell "alcohol" wrong on the first try.)

HEART

Drinking too much can damage the heart.

OR

Drinking for a broken heart won't help it mend any faster.

* * *

BRAIN

Drinking to forget your problems won't actually make them disappear. In fact, it might actually make some of your problems worse. Particularly if you have a drinking problem. Then you should drink less.

OR

Sometimes I have a drink to help myself be a little less doubtful. See, I've got this nasty habit of trying to anticipate the future, as I'm sure many of you do as well. But the future is an expansive place wait, actually scratch that. The future doesn't really exist at all. And neither does our past, only our experiences in the past, which form our bodies in the same way that wind forms the beach trees.

But this is about doubt. And I doubt myself a lot. I think of something, and then I use my mind to foresee its future and determine that either (A) it's not worth the time I'll spend trying to get there, or (B) the outcome is poor. So when I say that sometimes I have a drink to eliminate doubt, I don't mean that some-

I'M
BRAAAAINN!

times the synapses in my mind are so dismantled that I can no longer foresee cause and effect. THIS IS BAD. You can burn your face off this way. But maybe sometimes it's late at night and I want to relax with a glass of wine and maybe start that historical novel I've been meaning to read . . . well, in that case a little liquor goes a long way. This works! But then if I have too many (and for my tiny body, too many usually literally means two many) I will more than likely dissolve into a 1990s pop ballad slow dance party of one. Which is, frankly, bizarre to watch and doesn't really help you finish your taxes.

* * *

LIVER

Drinking too much will damage your liver.

OR

Keeps your liver on its toes? Seriously. Your liver will begin to grow toes if you drink too much. It's not cute. Some say that there are foods that are good for your liver, like raw onions, so eat some of those. Though that may not be good for your kisser. Or kissee . . . as in person you kiss.

→ I barely Know 'er

* * *

KIDNEYS

Drinking too much can really damage this relationship. Like forgetting to pick them up from school, spilling hooch all over their homework, hitting on their teacher during Parents' Day, collapsing into a fit of body-racking sobs so that they can no longer hate you but are trapped by the terrible burden of their own pity and who just asked if it was possible to buy more Cap'n Crunch because there was none left.

OR

Drinking too much can cause hepatorenal failure, which leads to, well . . . let's say making sure there is cereal in the house is an easier problem to remedy than that.

 YOUR KIDNEYS HAVE KID NEEDS!

WEIGHT

Too much of anything will affect your body weight. This in turn may affect your image of yourself. For me, drinking leads almost immediately to eating, but I've seen some people drink through dinner and forget to eat entirely. That's not good either. It's best to balance out the occasional excess by being aware and responsible. It's hip and nouveau. Putting the MOD in moderation.

Oops. I mean . . . Jokes, jokes, jokes.

How much CAN you DRINK?

B.A.C. (blood alcohol content)

(to where you once belong!)

DRANK! HOOCH XXX

	100	120	140	160	180	200	lbs.
1	🍸						
x 2		✓					
x 3			✓	✓			
x 4			☹		✓	✓	✓
x 5							
x 6							

✓ @ legal limit

☹ = ## slept in shower

* * *

SKIN

This one is easy. Alcohol is a diuretic and will dehydrate you. Proper hydration is the key to healthy skin. Therefore, if you've got preexisting skin baggage (like issues, not, like, under the eye baggage . . . though I think that drinking water helps with that too), make sure to pound a ton of water to compensate for your night on the town.

**** THING I LEARNED WHILE RESEARCHING THIS BOOK ****

Alcohol causes facial blood vessels to dilate (think of that jolly, sweaty, tomato look on everyone's face when they close the bar and turn the lights on) and repeated bingeing can lead to the vessels remaining overworked. Thus leaving your face with a permanent ruddy complexion.

Most extreme scenarios look like this:

Sweaty tomato

LIBIDO

It's easy to think that drinks with your beloved will lead to a night of raucous, kinked-out sex—and I find this to be true for the most part—but I'm still in my twenties and only now having the amount of sex I've always wanted. However, I've heard these recurring descriptions of drunken sex from some of my older friends:

"Sloppy."/"Gross."/"Bizarre."/"My back hurts, and it's not even from the sex itself but the fact that I slept on the couch."/"We were going for floor sex but then we spilled wine on the carpet and had to clean it up because we have in-laws staying this weekend. By the time we had gotten most of it out, we moved things into the bedroom . . . but *The Voice* was on . . . so we ended up falling asleep on top of the covers."

And while I might choose to believe that my sexual prowess remains masterful despite any form of impairment or inebriation . . . I may or may not have heard the following comments directed my way:

"Ha."/"I'm not sleeping in the bathtub."/"No. We are not having a threesome. You are just seeing double."

* * *

HYGIENE

Turns out the smell of second-day tequila oozing out your pores does not make the best impression. Same with second-day eyeliner. Sure, it's always good to be grateful that you made it into bed in a safe place, but not super fun to have your eyelashes caked together. In terms of clothing, my rule remains: "If I can take them off and they stand on their own, that wins them a round-trip ticket to Laundry Town, USA."

FUN FACT: I love a good drunk shower. Don't know why, but I really

SOAP NOT DOPE!

do. Be careful though! Only do this if you can stay upright. No sitting. That leads you to a one-way ticket to Sleep Town, USA. Stopping off at Pneumonia Town, USA, with a possible destination of Deadsville.

* * *

EARS

Do not use Q-tips when drinking!

* * *

literally just two squiggles

NOSE

Do not use Q-tips in your nose ever!

* * *

THROAT

I have a terrible habit of losing my voice in the morning. Be it from shouting over the din at the bar, spontaneous outbursts of karaoke, or laughing myself into a stupor in the corner, I feel that one of the most affected parts of my body (post-insobriety) is often my throat. Also, given that I love the sound of my own voice, the hoarseness and discomfort severely limit my ability to speak, which in turn suffocates my

ambiguous
gender is
ambiguous

soul, since I have so much I want to say constantly.

Here's a tip: If you feel yourself starting to clear your throat before every sentence . . . that's a pretty good indicator that it's time to practice your listening skills. Or switch to water. Quitter.

* * *

SOUL

While some people will argue that this (A) may not exist or (B) is certainly not part of our physical forms, I'm going to go ahead and boldly state that consciousness (at the very least) is an irrefutable part of the human experience. So what effect does alcohol have on this portion of being? Well, that's for you to decide. Like any healthy relationship, this will involve lots of patience and understanding. Not to mention motivation for change.

For instance, if you feel a deep well of sadness after a night of heavy drinking (a chemical occurrence, since alcohol is a natural depressant), it may be best to lay off for a little while and give yourself some time to recalibrate. Pick up a different hobby for a bit. Maybe writing a book? I hear that's a big thing these days.

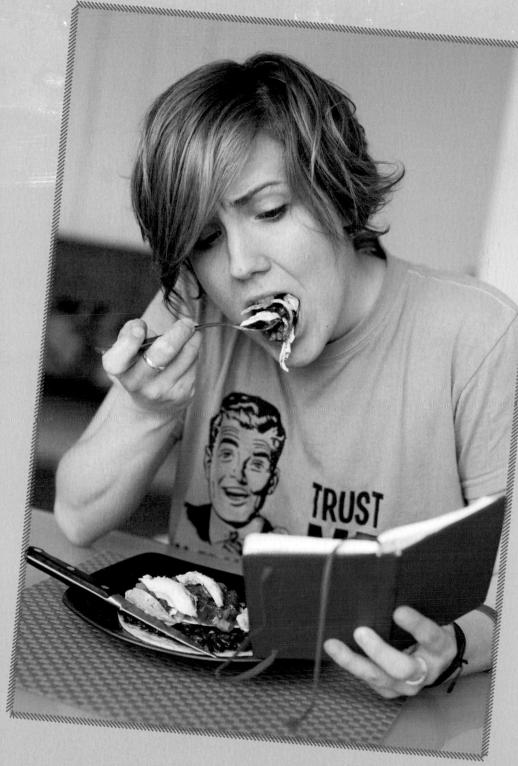

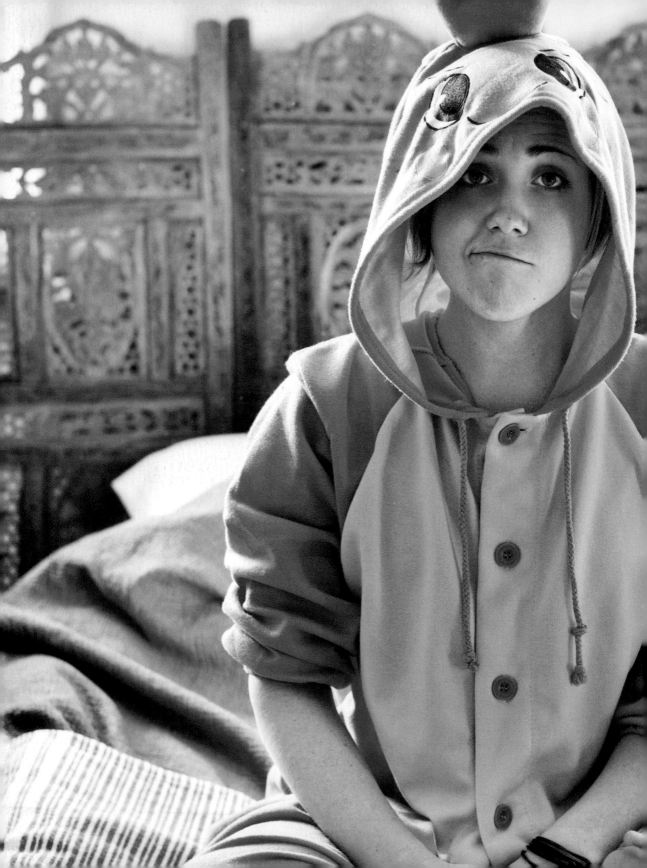

ADULTOLESCENCE

Savor the Cooking as Much as the Meal

You know how people like to tell you it's about the journey, not the destination? Well, as it turns out . . . they're right. But that doesn't mean that the journey you're on isn't going to go through long expanses of sucking miserably. Sure, people tell you that middle school is awkward, or high school is rough, or maybe college isn't even for you, but they don't warn you about transitioning into adulthood itself.

I like to call this terrible time your "adultolescence"—a secondary pubescence that takes place throughout your twenties and sometimes well into your thirties. For me, it began at the age of twenty-three, almost immediately upon graduating from college, and continues in varying forms to today. (Though if I'm being really honest, I can go ahead and say that the sleepless nights of "What am I even doing with my life?" probably began around the age of twelve and hadn't, until very recently, even started to go away.)

Adultolescence begins like this: The patterns and routines that once determined your path (school, living at home, etc.) align anew and suddenly you find yourself in the midst of an emotional cyclone that has your adrenal system oscillating between utter depression and sheer panic. You may find

that your friend groups have split after the bond of shared education or proximity ends. If you're lucky, though, you may find yourself surrounded by friends who share the same rockin' boat.

For me, my adultolescence truly began when I moved from Berkeley to San Francisco to work as:

1. An office manager/personal assistant to an eccentric former makeup artist who ran her own boutique management agency out of the basement of her home.
2. A cubicle jockey who specialized in proofreading Japanese instruction manuals that had been translated into English.

(I was one of the lucky ones with employment in 2010! Bask in the glamour of the detached twenties elite!)

The Basement Agency mentioned above was about three blocks away from the apartment I shared with my two best friends (who were a couple, and I was a brokenhearted OKCupid single ready to mingle . . . more on that in PART 3: SO THIS IS LOVE). The owner of the business lived in Cabo for most of the year and rented out the top portion of her home to tourists visiting San Francisco. (PRO TIP: September is the best time for Bay Area basking.) This meant that while running the business from below, I was also given the task of monitoring the temporary tenants as acting property manager. It was solitary work. My routine consisted of turning the volume of the computer all the way up while I napped on the floor in between Skype calls. I worked from 8 a.m. to 5 p.m., with a thirty-minute lunch, and since I was only blocks from my home I would walk back for a peanut butter sandwich with a side of really foul cheap whiskey.

Four days a week, I would leave at dusk to take the Muni into the financial district to slam coffee and proofread. I called this "white-collar mining." Basic typos were like gemstones nestled in white stacks of paper dense as rock. My coworkers consisted of a cast of characters whose personal details I will spare out of respect for their (possible) wishes to remain out of the public eye. Frankly, I enjoyed this work (and their company) a great deal because it meant that I did not have to be alone. There is great camaraderie in mutual misery, and I would take hand cramps and coffee chats over floor naps and basement doors any day.

Then I got transferred to the New York office and My Drunk Kitchen happened and then became now.

As I write this, though, I look back at the person I was during that time. Someone who felt so deeply lost because she did not have a destination she was working toward. Someone who was disenchanted with the adulthood she'd longed for and trapped in the anticipation of a future she couldn't see. Someone improvising the present moment, but with much *ennui* and very little *joie de vivre*. (I think cookbooks need to have occasional French in them, *non? Roux. Poulet. Julia Child.*) I was not the person I wanted to be, and I didn't even know who or what I wanted to be ultimately. What did it matter that I was young with no children and a bit of spending money on the side? I was going to be miserable because there was simply no other way to be.

Frankly, I think that part of why this transition into adulthood is so hard is that *no one prepares you for it.* They don't talk about the existential crisis of modern existence in health class! They don't tell you that your friends are going to get married while you're still single and it's going to make you question everything! And they certainly don't tell you that happiness is not a lasting, continuous expression of ecstasy, but much more likely to be a sense of resignation after a long day at a job you hate while you return to whatever home you have to find that your roommates left all their dishes in the sink and you just can't even. You just can't.

I don't know why people teach kids about "pimples" and "hormones" and "armpit hair," and refrain from telling them that if they don't achieve their billion-dollar dreams at the age of twenty-one, there will still be much more to life. And that when you fail at your first job, it isn't going to be the end of the world. And eventually you will realize that each person's world is different and your *only* job is to figure out what your best world can be.

Let me give you an example of how this might look.

Let's say in the setting of a kitchen.

Two people are preparing for the same potluck.

Person A decides to make the kale salad that they always bring because it's good, good for you, and consistently brings favorable reviews from the other attendees.

Person B decides to try their hand at baking a soufflé, because, hey, the potluck happens to be at their place and frankly they've never made a soufflé before so maybe it will be super good and great, who knows?

Person A leaves for the farmers' market to buy the kale they know they need along with some other items for the household *en générale*. (More French!!)

Person B goes online to try to find a good recipe for soufflé that's relatively easy but also hey there is a new article on Buzzfeed about the twenty-seven highest-looking dogs and cats so gotta peep this first.

Person A returns from the farmers' market with produce and a freshly baked loaf of bread. Also, some locally pressed walnut oil that will go very well with the dark fig balsamic they've been saving for a special occasion. But let's be wild and just make that special occasion today. I mean, why the heck not!

(Apparently, Person A is the type of person who uses the word "heck" so I think you can tell a lot about them now.)

Person B returns to the kitchen after e-mailing the article about the twenty-seven highest-looking dogs and cats to all of their friends who are coming tonight with the subject: "THIS IS US IN 4 HOURS." Pulling out a cookbook from somewhere they read about soufflés for a second before deciding to make a snack. There's still an hour or so until the potluck after all. So might as well have a snack. Maybe even a nap? Soufflé is like a dessert thing anyway so can happen at the end of the night.

Person A has now washed and massaged the fresh kale. Next they will drizzle it with rice vinegar, a splash of balsamic, and some olive oil. Then Person A is elated to discover that there are, in fact, some pomegranate seeds left over from last night's Moroccan couscous cooking adventure. What luck!

Person B has decided to nap and is napping.

Person A is going to lightly toast some almond slices and toss them in before leaving.

Person B has woken up with twenty minutes left before guests start to arrive so basically this means that there is no choice but to forsake all hope of cooking something themself and instead just clean the place. Hosting at all is enough.

Person A leaves their home, arriving ten minutes early to the home of Person B.

Person B is so stoked about the salad! Man, Person B would love to learn how to make it sometime.

Person A could teach them.

Person B thinks that's a great idea . . . also . . . would Person A mind helping with the dishes in the sink real quick?

Person A doesn't mind at all.

So, the question is this: Which person is happily surviving their adultolescence? Maybe even flourishing in it? Which person do you want to be? The answer?

TRICK QUESTION! IT'S BOTH PEOPLE! THEY ARE BOTH HAPPY BECAUSE THEY ACCEPT THEMSELVES FOR WHO THEY ARE!!!!!

You see, it doesn't matter that Person A is clearly good at doing things and knows all about planning, timing, and follow-through, whereas Person B seems to be someone who can't get anything done but for some reason still has friends kind enough to help with the dishes. Basically, they both have learned how to love and live in whatever experience they are in—whether it's on the way toward accomplishing something greater . . . or not. What matters is that both people aren't judging themselves, or each other, which is really the only thing you can hope for while you're trying to make it through adultolescence. In the section ahead, you will find recipes that you can make or bring or serve at any sort of gathering. Or even make for a party of one. Drink pairings ~~required~~ included.

But let me tell you one last thing. As it turns out, that feeling of being lost or listless or never achieving your potential doesn't contain itself within any certain decade of life; it just lives in you until you learn how to cope with it or let it go. So, maybe this next section of the book could apply to anyone no matter what age they are.

Either way, in the end, becoming an "adult" really only means one thing:

You are now obligated to bring dishes to potlucks. Maybe even sometimes host one yourself.

Isn't that horrifying?

{ TINY SANDWICHES }

Small packages often contain valuable things.

—FROM THE COLLECTION OF THINGS
I SAY WHEN PEOPLE COMMENT ON MY HEIGHT

Unlike when you are an adolescent, in your adultolescence, it is no longer cute to constantly comment on the things you hate about yourself. Frankly, everyone has insecurities. And for the most part they surround issues that are completely outside of our control. For me, one of my main self-qualms is that I'm not the tallest person. But I'm also not by any means the shortest person either. However, for some unfortunate reason I often seem to find myself in the company of rather tall people. Women who average five-ten and men who average six feet. And in my mind's eye I like to see myself as the height and width of a friendly lumberjack.

I'm not, but good things come in small packages and can bring you lots of tasty comfort. Just like having a tiny sandwich.

Cocktail

In keeping with the theme, I recommend drinking an Underberg, because they are adorable.

Ingredients

* 2 slices of bread (pick your favorite)
* inside parts (again, up to you, what we have pictured here is PB&J)

Instructions

Make yourself a sandwich of your choosing, but instead of just eating it right away, cut the sandwich into both horizontal and vertical thirds, creating a grid. Then pull apart and serve as fancy, ironic hors d'oeuvres.

 Your body-conscious friends will delight at this seemingly low-carb treat that reminds them how much they miss sandwiches. And you will be happy to know that size doesn't matter. And in fact, by giving them just a taste, you may leave them wanting even more.

Life Lesson

Say nice things to yourself about your sandwich soul.

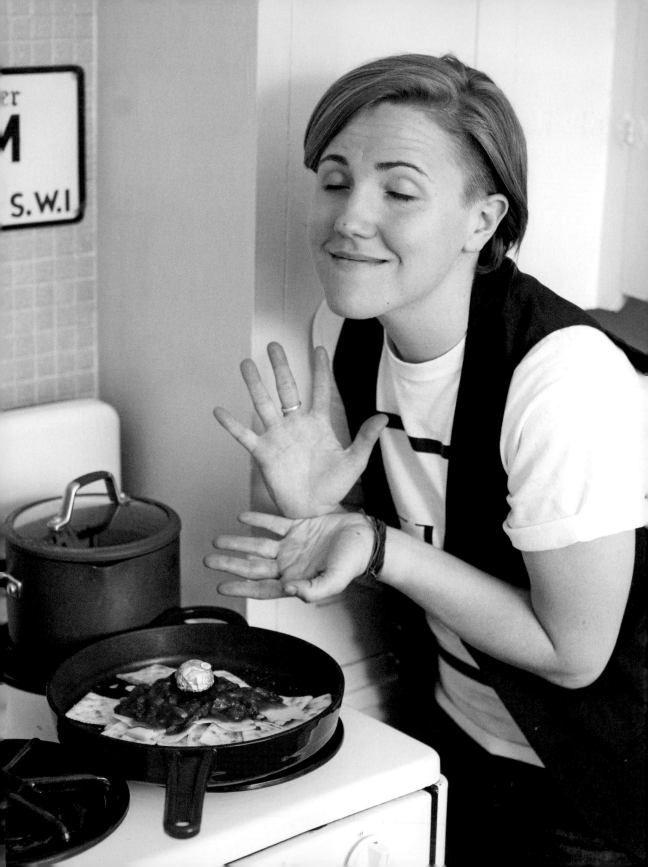

{ SALTINE NACHOS }

Invention, it must be humbly admitted, does not consist in creating out of void but out of chaos.

—MARY SHELLEY

You know how you set a goal for yourself but sometimes you feel that you don't have the resources to achieve it? Well, if you don't think you can get there with what you've got . . . fear not! You can still aim to do your best and that will be one step closer, don't you think?

For instance, let's say you want nachos, but you don't have any tortilla chips . . . well, that's okay! Sometimes the nachos you want for your life won't be made of tortilla chips. You can try saltines instead. Don't give up, just make do.

Cocktail

Martini. Because that sounds capable and shit.

Ingredients

* a bag of saltine crackers (if stale, that's okay too, no judging)
* salsa
* cheese
* martini olives? Because that's what you're drinking?
 I think the red things are pimentos.

Instructions

No judging. Just progress. That's the theme of this meal. You want nachos, and dammit you might not have the traditional ingredients, but you've got the first steps: drive, determination, an appetite for success, a thirst for conquest. Maybe you don't have salsa? No problem. Just use pasta sauce. If anybody turns their nose up at your creation, just turn away from them and keep your eye on the prize.

Seriously. Because if you put it in the oven it might be burning.

Life Lesson

In adulthood, you will still have to overcome difficulty, but you will have increased your ability to problem-solve.

5 WAYS TO ARRIVE AT WORK HUNGOVER AND MAYBE GET AWAY WITH IT

1. **Plan ahead.** Before a night of partying, make sure you don't have a 9 a.m. staff meeting scheduled for the following day.

2. **No shirt, no shoes, no paycheck.** Make sure to keep a change of shirt and an extra pair of shoes in your car. Just in case you lose one (or both). Also, make sure not to lose your car.

3. **Blame the client.** Pretend you were out closing a deal with somebody somehow and be like, "Oysters and martinis! Who knew they would lead to trouble?" (Note: This does not work if your boss watches *Mad Men*.)

4. **Take a long lunch.** And sleep in your car as much as possible. (Again, only works if you didn't lose your car when you lost your shoes and shirt.)

5. **Booze the boss.** Try to get your boss drunk too. Though this one can be hard to execute . . . especially if you were in different places the night before.

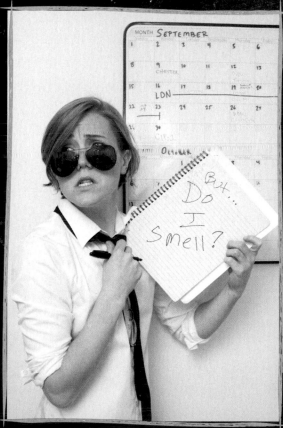

{ FRITO TAQUITOS }

A cada necio agrada su porrada.

—Fancy Spanish proverb

For those of you wondering what a taquito is . . . well, maybe you should leave your home state at some point this year.

(JUST KIDDING! ALSO I UNDERSTAND THAT TRAVEL IS EXPENSIVE AND NOT EVERYONE HAS THE MONEY OR TIME TO GO GALLIVANTING AROUND THE COUNTRY FOR THEIR INTERNET SHOW. TOTALLY GET IT!)

A taquito is basically a soft tortilla that is layered with ingredients and then rolled to make it easiest for aiming straight to the face. Picture Homer Simpson eating hot dogs.

Cocktail

Michelada. Because we are being multicultural right now?

Ingredients

* corn tortillas (preferably smaller-ish)
* beans! or beef! or whatever!
* taco seasoning (just a dash, alt: the whole packet)
* for added crunch I recommend Fritos! Due to the rhyming factor.
* cooking oil
* sober supervision WARNING!!!

Instructions

The first step in making a taquito is to lay out the tortilla.

The second step is to smear goodies inside.

The third step is to CRISP FRY it. This basically means using a decent (but by

no means large) amount of cooking oil and heating it up and being careful of your fingers and body parts as you lightly fry the tasty treat.

Life Lesson

Sometimes you need to embrace your compulsions.

Just go with it. And like the second step of taquito making, smear your life with possibilities. Ooh . . . that makes me think of "shmear" . . . maybe there is a way to make a Jewish taquito?

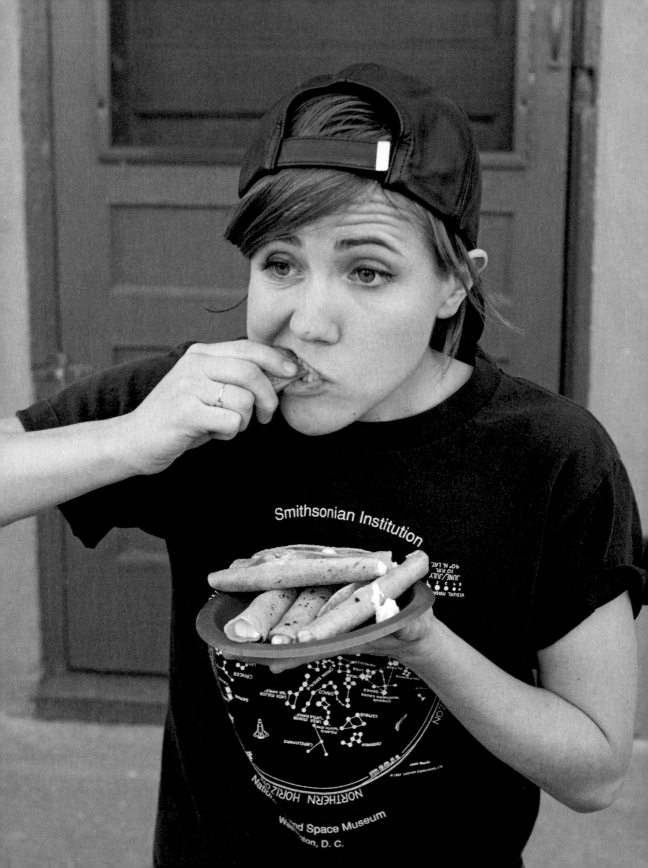

{ JEWISH TAQUITOS? }

Maybe there is a way to make a Jewish taquito?
—*MY DRUNK KITCHEN*, PAGE 57

Sometimes as an adult you have to be spontaneous. Just make sure you're not also being racist in some way.

Cocktail

Wait . . . is it racist to call something Jewish just because I added cream cheese to the recipe?

Ingredients

* Because seriously the only difference is that I added cream cheese.

Instructions

But it can be any type of cream cheese you want!

Also, I wonder when people started to affiliate the Jewish population with bagel making.

A Very Brief and Only Semi-Accurate History Lesson

Bagels were introduced to American cuisine by Jewish immigrants of Polish descent. They came to New York, brought bagels, and were universally beloved by all. That's basically the extent of my knowledge. Oh, and bagel means "ring" in Old German speak. According to my memory of that one bagel bag from which all facts of this history lesson stem.

Life Lesson

Looking at this recipe it strikes me that the word "quit" is nestled inside "taQUITos." So let's take a moment to talk about that. Personally? I'm a big quitter. I can't help it. Maybe it's the ADHD or maybe it's my own warped idea of perfection. Who's to say? I can tell you one thing that might help you advance in life, it's something my dad told me once that I thought was really nice. I was listing all the odds against me, and why I wasn't going to be able to succeed, and why there was no reason to begin to apply. He said,

"The only guarantee is that it *can't* ever happen if you don't try. So if you're looking for something that's 100 percent . . . there it is."

HANDY HOSTING RECIPE

Unfortunately, your friends have started having group gatherings at their houses and it's a little awkward that you haven't had one at yours. So dust off that couch! Get the weird goop off the side of the remote control! Find your keys! You're gonna be the emcee tonight!

But don't panic, here is something you can make in the time it takes for them to get out of their cars and knock on the door.

{BRUSCHETTA BITES}

Like bagel bites except fancier because you are an adult now who does adult things.

Cocktail
Chianti is the Key Auntie you want to invite to this snackfest.

Ingredients

* tiny toast squares
* croutons could work too probably
* pico de gallo (unless you're having a party with a bunch of friends from West Hollywood . . . then it's pico de GAY-o! heyohhhh!)
* balsamic dressing

Instructions
Don't add balsamic dressing, actually. Just add the vinegar if you have it. But if you don't, maybe skip that part. That sounds a little gross, doesn't it?

A bruschetta is a tasty, tasty fresh Italian appetizer that is really good for eating. You can chop up fresh tomatoes, and sprinkle oil and vinegar, fresh basil, and some pressed garlic on them, or maybe a garlic-infused olive oil would be nice.

But if you're not going to do any of that you can always just scoop pico de gallo onto croutons and call it a day. You've got better things to do anyway . . . like making this cat!

Life Lesson
It's perfectly acceptable to put kitty cat ASCII art into your first published work. That's something I just decided right now.

```
              /\_/\
         _____/ 6 6 \
   ~~~~//____  <@> /
        ( __ m) _m_m)
```

{ PIZZA PIE CHART }

Friendship is unnecessary, like philosophy, like art. . . . It has no survival value; rather it is one of those things which give value to survival.

— C. S. LEWIS

This much I know is true: it is impossible to survive adulthood without the company of good friends. People give a lot of time and thought and energy to their romantic relationships, but they shouldn't devalue or ignore the importance of friendship. But recognizing good friendships can be hard . . . so I've developed this tasty infographic to help you out!

Conduct your own social science experiment by portioning out different toppings to different sections of the pizza and serving. Then make some rash generalizations.

> **PRO TIP:** Always make an infographic. Always. Just always.

Cocktail

Pinot Noir! Because the more . . . pee . . . no? #reaching #NBCrainbow

Ingredients

* ready-bake pizza dough (because who you fooling?)
* any red pasta sauce
* onions (because yum?)
* olives (because also yum?)
* cheese on cheese on cheese (because cheese?)
* bell peppers (THIS WILL BE HOW YOU TELL IF SOMEONE IS GROSS)

Instructions

Sometimes when you put bell peppers on a pizza they bleed into the flavor of the entire pizza. I mean, they are just something that people *accept* on their food, you know? Nobody is ever like, "Oh yes! Bell peppers, please! Don't forget those taste machines!"

 ## Life Lesson

Accept all people for their true selves.

However, if someone picks up a slice of bell-pepper-coated pizza . . . they are clearly just accepting the life that's passing them by. Immediately hug them and tell them that they are worth more than that.

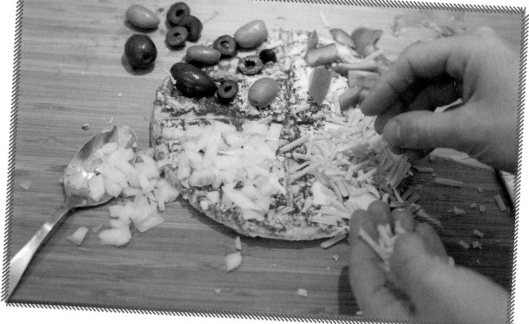

{ PIZZA CAKE }

You're simply the best,
better than all the rest,
better than anyone,
anyone I've ever met!

—TINA TURNER

Being a host means impressing people . . . and this is seriously like the best.

Cocktail

Doesn't even matter, because you're about to eat a slice of heaven.

Ingredients

* 4 or 5 or 10 of your favorite kinds of pizza

Instructions

Bake those pizzas. Layer those pizzas. Slice and serve like cake. Accept applause for your ingenuity. Careful, there might be some tears shed.

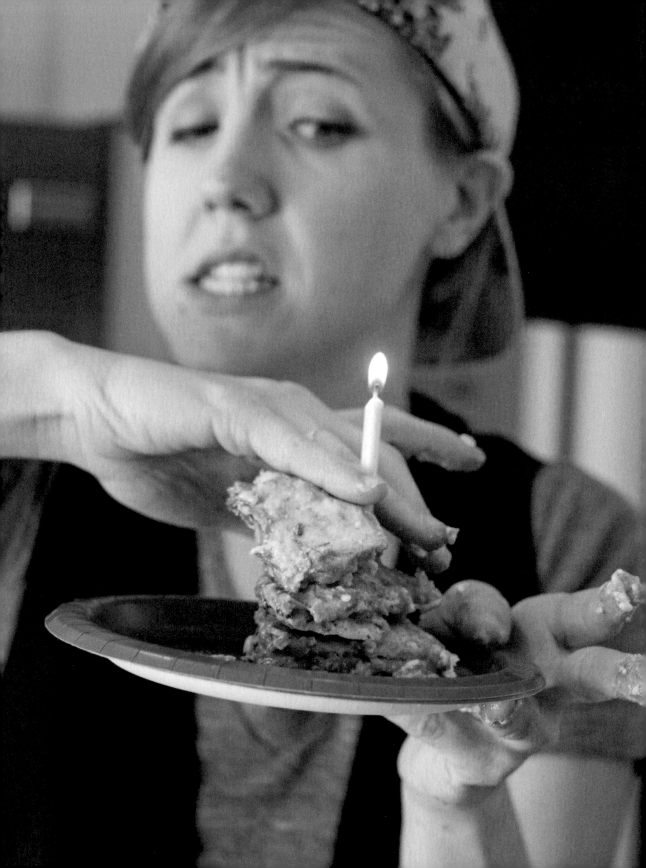

Life Lesson

Because sometimes you really can have it all.

{ HOT RODS }

It tastes like burning.

—RALPH WIGGUM

It's important to challenge yourself to try new things. And things are better when they are spicy. But sometimes people don't like that. I'm not one of those people, but some people are those people. Life is a mixed bag. Of pretzel rods, apparently.

Cocktail

Milk contains a natural neutralizer for spicy foods called "casein," so just in case(in) of emergency . . . chug a dairy-based drink! Like Kahlúa. Ooh, maybe add some Kahlúa to a nice chai tea . . . I bet that would be delicious!

Ingredients

* chili powder
* salt 'n' peppa
* ziplock bag
* pretzel rods

WHAT DID THE MILK SAY to the COW?
I'm mooo-ving... Out?

Instructions

Put seasonings in bag. Put pretzel rods in bag. Shake. Whoa, not so hard. Get a little dizzy. Debate about whether or not the chai-Kahlúa drink was a good idea, because it seems to be coming back to discuss visitation rights with the outside world.

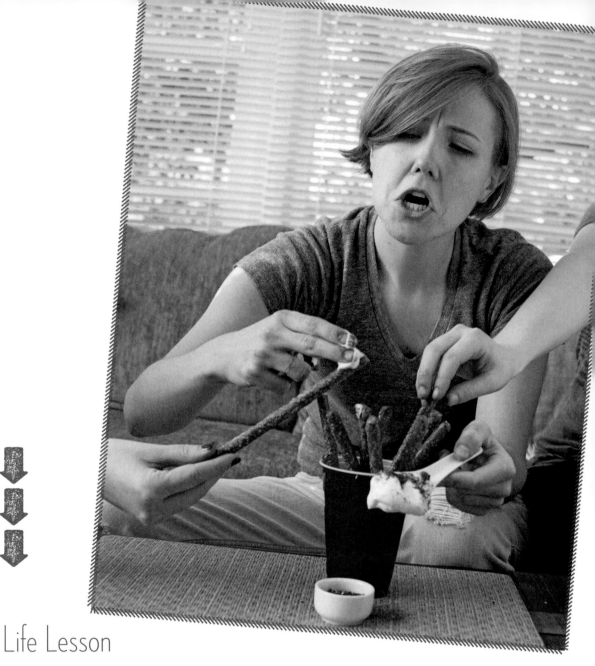

Life Lesson

Sometimes you have good ideas and sometimes you have bad ones.

Follow your heart about what you are and are not willing to try out.
Except for heroin. Just don't do drugs, kids.

{ CRUNCHY ROLL }

Wealth consists not in having great possessions, but in having few wants.

—EPICTETUS

Let's face it: adulthood means that sometimes you're broke. Sometimes *we're all* broke. (Like financially speaking. Not like emotionally spent. Not like talking about years of personal baggage. Though that's there too, obviously. I mean, I get drunk by myself in a kitchen, for goodness' sake. That can't be healthy! Though true fact: my therapist says that doing YouTube was the best thing I've ever done for myself . . . so that's a nice thought.)

ANYWAY, point being that sometimes you really want to go out to get sushi but that shit is expensive so you can't always afford it. Plus there is a lot of mercury in fish these days. And if you want to get mercury-free fish you really have to spend the big bucks. Healthful living is such a money suck.

Cocktail

Is there a sake equivalent of Two-Buck Chuck?

Ingredients

* tortilla
* cheddar cheese
* potato chips
* Sriracha
* avocado (If you have!
 alt: store-bought guacamole)

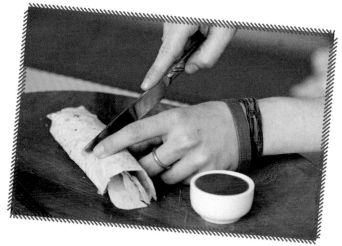

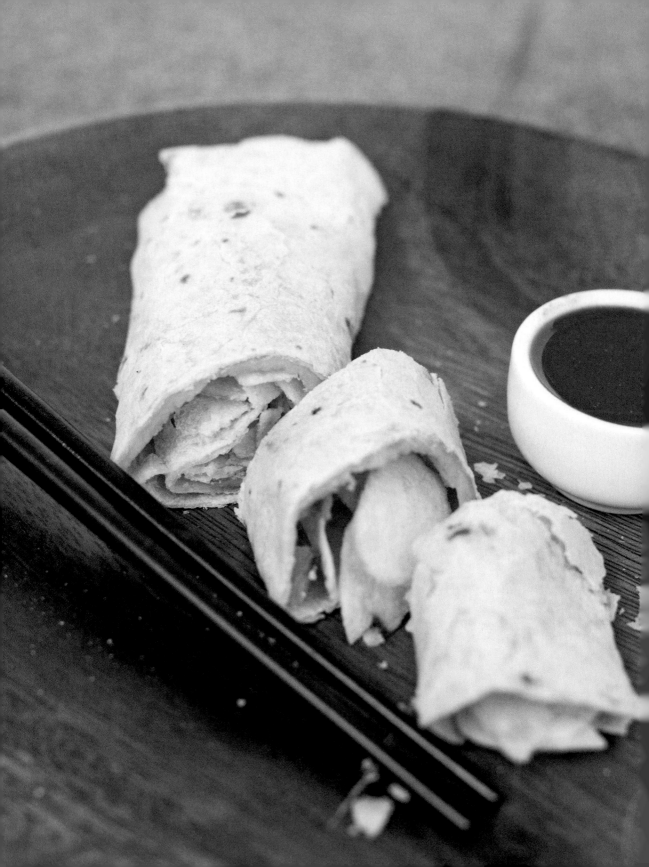

Instructions

Take a tortilla and resist the urge to bite it into a little face shape. I love doing that.

(But seriously, if you're hungry go ahead and do that to one tortilla and then cook with another. Worst-case scenario, you're no longer dining alone! But instead with a creepy-semicannibalized-tortilla-observer-friend?)

Lay your tortilla on a frying pan and sprinkle cheddar cheese over it. Then add a fine layer of potato chips. Grab some potato chips to eat as the cheese melts. Turn off heat source. Let cool . . . BUT NOT TOO LONG BECAUSE YOU NEED THE CHEESE TO BE MELTED STILL! Okay, now roll it into a shape and slice fancy style. Garnish with Sriracha and avocado. Enjoy!

Life Lesson

You might not be at the standard of living that you aspire to achieve. But be patient. And sometimes eat some comfort food that you've sliced into a sushi shape.

WHY BRINGING BAKED GOODS TO THE OFFICE IS GOOD/BAD

You work in corporate America. You've got a cubicle. Or maybe you've got your own office. But at some point you definitely paid your dues in your cubicle. Maybe it was a shared cubicle. Aren't those the worst? When I worked as a proofreader (hilarious considering the amount of grammatical errors in this wordery*), I shared a cubicle with three other people who had been there much longer than. Also, I was only part-time so you know how low that put me on the totem pole in terms of decorating my office space.

But I learned a lot from working there. A lot about office politics. And a lot about how people can find any reason to resent something if they are disgruntled on the daily.

For instance, let's take the example of bringing baked goods to the office. If this has occurred at your workplace, you were thrust into one of two positions:

> The person who brought the baked goods and hopes that people like them.
>
> The person obligated to like or sample the baked goods that have been brought.

Now, isn't it just so awkward? Especially if they made them from scratch? Because then you're like, "Well, now I have to try them even though I really don't want to," or you're like, "I hope people don't feel like they have to try them, I just had leftover batter and didn't want it to go to waste." It's a vicious cycle.

And what about if said baked good has been purchased at the store? Then what does that say? Why on earth did this person feel compelled to go to the grocery store and buy things for the office? That's not their job. That's why we have someone designated to stock the kitchen. I'm stressed out just by typing this.

I don't know if you guys have ever felt that way, but I have, many, many times. Mainly because I remember getting a lot of flak for declining.

"Oh, you don't like this cookie?"

"Don't worry, I used low-fat butter . . . are you dieting or something?"

"It's my grandma's recipe. I miss her every day."

*Wouldn't that be a cool word if it was real?

And the only reason is that I just don't like sweets! Nobody ever decides to bring the office savory snacks! If someone walked in one morning with a bucket full of jerky, you can bet your sweet patootie that I'd be all up in that 9 a.m. sodium bomb. Like for real though.

Anyway, if you're a neurotic people pleaser like myself, here is my advice for how to handle the situation:

Sneeze into your hand before reaching into the communal bin.

No one will ever bring you a donut again.

{ DICK-TATERS }

In politics, stupidity is not a handicap.

—NAPOLEON BONAPARTE

College is that time of life where you meet a lot of people who are majoring in PoliSci. This is also the space where you will meet your first libertarian. Or you yourself might become a libertarian. For a period of time in college, I was librarian. That's unrelated, but felt relevant here.

Here's an excellent hosting treat for such types!

Cocktail

Whatever you have . . . have it over ice.
Keep your head cool in a hot debate.

Ingredients

* mashed potatoes
* Tater Tots
* tiny adorable wieners
* teeheeehee

Instructions

This is kind of one of those recipes you make if you have a roommate who already made half the ingredients and has now left them in the communal fridge marked "FREE!"

So! Take some leftover mashed potatoes and some conveniently also leftover Tater Tots and put little cocktail wieners inside. Then bake to reheat. Then giggle

to yourself. Then serve to people. Best to leave some extra wieners out just in case your guests can't get enough of the D*.

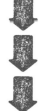

Life Lesson

Politics is a sensitive subject.

And I think it's because everyone wants to feel like their needs matter. I wish that debates included more "Yes, and . . ." or "However, you're stupid. Remember that time you shut down the country because you didn't want to participate in government?" #sorrystillnotoverit

*As in diplomacy, pervert.

{MACARONI AND PEACE}

Peace and friendship with all mankind
is our wisest policy, and I wish we
may be permitted to pursue it.
—THOMAS JEFFERSON

Now, as a grown-up person who does things, maybe you've traveled the world and maybe you've thought about global conflict and maybe you've drunkenly espoused your perfect solutions to the seemingly unbeatable crises of incompatible worldviews.

This recipe is a plea to make two seemingly opposing worlds come together as one . . . for the greater good . . . of your digestive system.

Cocktail

A lighter red wine, such as a Pinot Noir.

Ingredients

* a box of macaroni and cheese (deluxe, because you deserve it)
* frozen peas
* Sriracha (optional)
* barbecue sauce (optional)
* ~~ketchup~~ (not an option . . . not a factor . . . not ever)

Instructions

First things first: you're going to have to boil some water to cook your noodles. At this point you should be able to do that on your own. Go for it. I'll wait. But not for too long. I've got a fine bottle of wine that's looking to dine.

Now that you've gotten the water going, open the box and pour your noodles in. Whatever type of mac you like is fine by me. Personally, I would suggest Kraft Deluxe Macaroni & Cheese Dinner because it's got a rich cheese packet that is fun to squish with your fingers while you wait for the water to boil.

Once your noodles have cooked and started to float on their own, call a friend and ask them to come over and strain your pasta because you're drunk again and don't want to burn yourself. Hopefully the last time you made them something it was delicious so they will be enticed to do so. . . . Odds are that this isn't the case, but they might come over anyway out of the goodness of their own heart. You've got some good people.

Noodles ready for splendor? Squish all the gooey cheese out of the packet and onto them. Yeah, girl. Get it. Don't lick your lips too openly. And try not to speak to the pasta directly. Your friend is still there, after all.

Add additional cheese because hello duh.

Finally, open the bag of frozen peas and dump inside! Silence your friend's protest by assuring them that you've totally got these and that you have your own cooking show and that really have you ever led them astray? Before they can answer, squirt some Sriracha into the pot and shove a spoonful in their mouth. Gently, of course.

Once they come down from salivary nirvana, make them a drink and a bowl. Then catch up for old times' sake. Even if you see each other every day.

Life Lesson

Some people might give you some flak for a new idea before you get to test it out. Ignore them if this discourages you. But if you can't get past it . . . then next time you have a new idea you want to try,

JUST DO IT FIRST
and then tell people about it.

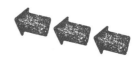

Sometimes I find that discussing an idea before executing it can take the wind out of my sails a fair bit.

Oh, also, give peas a chance.*

* I'M SORRY, I HAD TO DO IT.

{ SWEET DIP }

It's okay to say no sometimes.
—THINGS THAT ARE TRUE

In life, you encounter many different types of people. For instance, have you ever met someone who is just a little too nice? Like, they go too far to be kind? To the point where it might actually be negatively impacting their own lives to do certain favors that they have offered you? Crossing that fine line between slight inconvenience and outright masochism?

What I mean to say is that I have a friend who . . . kind of drives me out of my mind. She's pleasant to be around! And is always at the ready with interesting facts or information! Constantly available . . . but then sometimes she says things . . . or does things . . . that are so passively self-deprecating that . . . I just can't. It makes me so frustrated. But the conflict is that I like her company so much! She's like a pleasant drizzle of caramel along the top of a cheesecake. A dollop of chocolate sauce on the tip of a strawberry. Just the barest hint of marshmallow fluff on a graham cracker creation.

But imagine that all at once. In bulk.

It would make you kind of sick to your stomach, right?

Cocktail

What's the opposite of a sweet liquor? Gin? That tastes like trees.

Ingredients

* maple syrup
* whipped cream
* chocolate sauce
* caramel sauce
* marshmallow fluff
* jam
* jelly (that strawberry goo you find sometimes on the side of your plate at a restaurant)
* ladyfingers

Instructions

Put everything in a giant bowl and serve to said friend. Serve with ladyfingers. Make an analogy about how everything is better in moderation. Even giving to others. Give them positive reinforcement. Send them out the door. Ask them to bring back the bowl whenever is convenient for them.

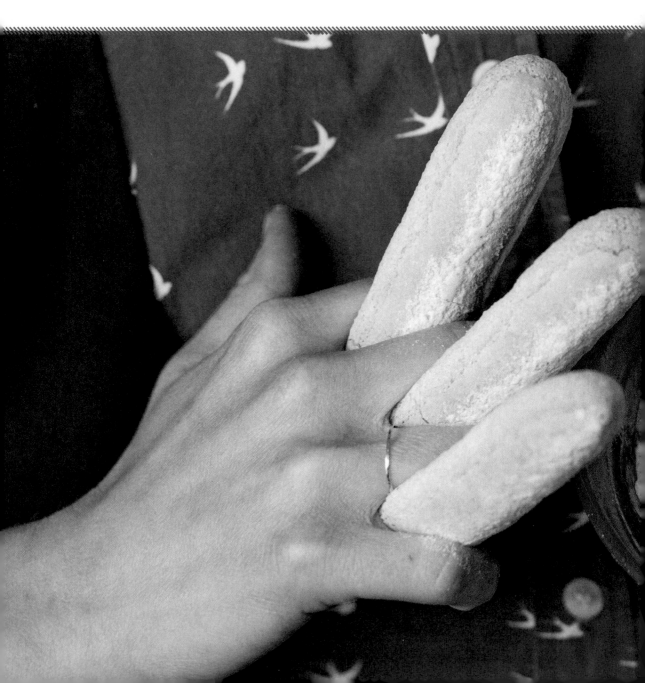

Seriously though.

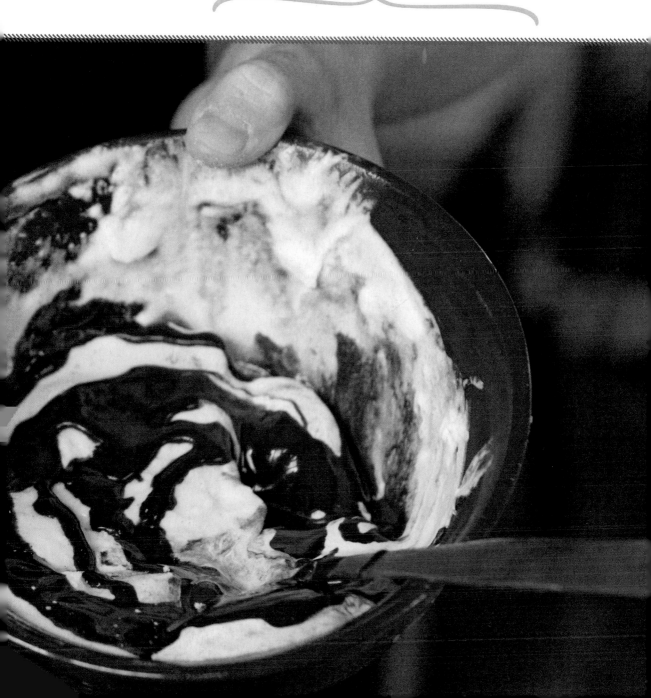

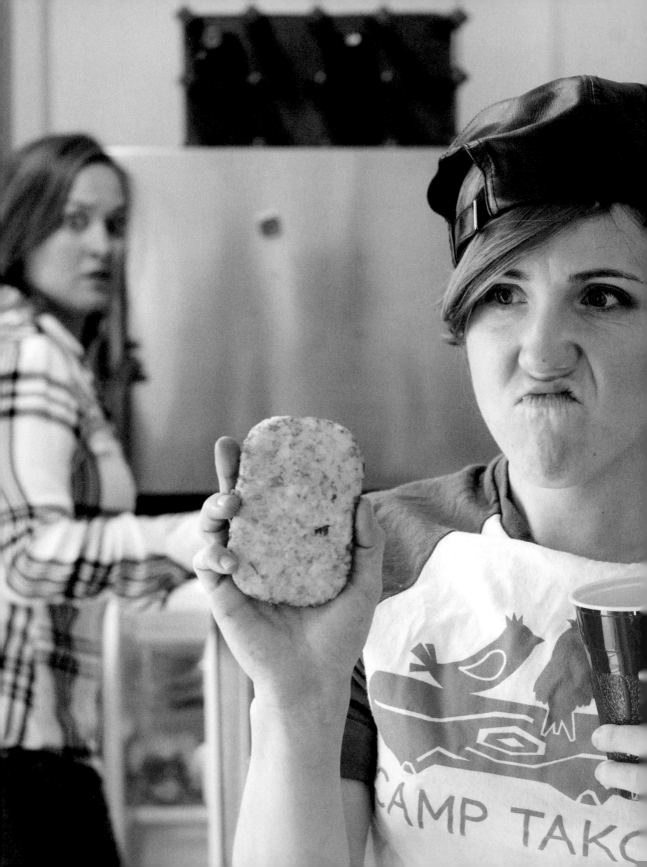

{ HASHTAG }

> Drink because you are happy, but
> never because you are miserable.
> —G. K. CHESTERTON, *HERETICS*

Has this ever happened to you?

It's after 2 a.m. and things are starting to get a little boring. You can tell that people are slowing down, passing out, making out, and just generally tapping out for the night. Unfortunately, you've got some unresolved aggression that's starting to manifest because you don't want the night to be done. If the distractions are over that means that you're going to have to face the silence of your own empty heart.

But here is something you can do instead!

Cocktail

If you start this game, then you probably lost King's Cup.

Ingredients

* something that has been upsetting you about your life lately
* avoidance
* insecurity at not being the center of attention
* frozen hash browns (alt: leftover hash browns from that morning)

Instructions

Unfreeze your last crop of hash browns and chase people around your house slinging tots. Insist that it's fun. Don't stop unless someone starts crying. Then stop so you can take pictures to post on Facebook later. Or start a website called Hot or Tot.

Life Lesson

Sometimes, for a combination of reasons involving real-life circumstance, you find that you (or a friend) have been tending to get too drunk lately for no reason. And then starting to become unnecessarily aggressive and insisting that everyone KEEP HAVING FUN. Shots at 4 a.m.? Maybe . . . but does everyone seem like they want to take shots? Or are they all avoiding eye contact and maybe checking out their phones?

Just remember, sometimes it's okay for the party to be over.

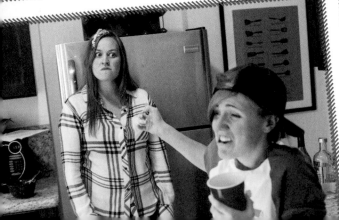

{ THE SADDEST CAKE EVER }

Diet food is for lazy people.

—ICE-T

There comes a time where we all look at our bods and think, WHOA WHEN DID THAT HAPPEN?!? This usually occurs in your mid-twenties.

Now, I personally don't care for it, but some people believe that extreme dieting is a good way to get skinny quickly. However, if you've got a sweet tooth, this can be very difficult. So, why don't you give this a try and let me know how it turns out?

Cocktail

Very measured shots of vodka. No freestyle pouring for this skinny minnie.

Ingredients

* rice cakes
* vanilla frosting (because who knows, maybe food coloring has calories?)
* stale old candies you found in the junk drawer (optional)

Instructions

First, dust off that bag of rice cakes you have in the back of the pantry. Are they still good? It's better if you let time pass until they are rock hard, as this will deter you even further from eating. Same goes for any old colorful candies

you can find. Remember, the point of this is not that you want to eat it, but rather that you feel better for not being able to eat it.

Next, put your finger into the icing. If it's your roommate's icing, then apologize. Not just for ruining their property, but in general for being such a moody asshole lately since you started this diet.

Spread the icing around and stack the rice cakes on top of it. Then take the candies and stick them on the top rice cake so they make a face that shows your true feelings.

Life Lesson
I genuinely don't believe in dieting.

I think that placing an end marker on when you're going to give your body good foods is weird. I feel like if you are having trouble with the way you look (and there's not a genetic predisposition to obesity or something), then you might want to think about changing your lifestyle on the whole.

Besides, have you ever heard someone talk about the calories in a beer? Talk about a buzzkill.

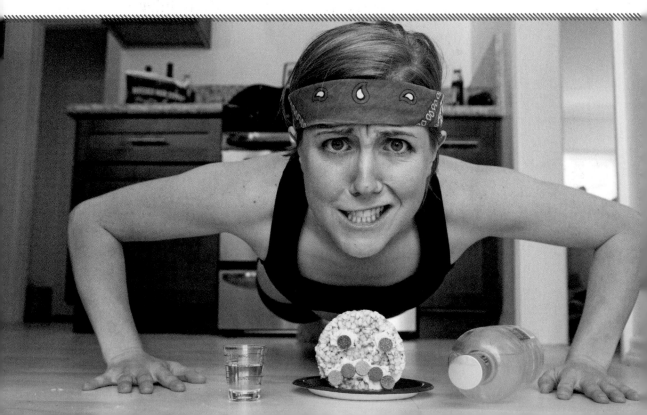

IF YOU ARE OVER TWENTY-FIVE PLEASE READ THIS

Hey . . . it's me . . . um . . . I don't know how to say this, but . . . I'm leaving you. For good this time. Now, I know we talked about this before, remember? When you were thirteen or so? Well, I'm serious now. There's no going back. You're going to have to learn to live a life without me, okay? I can't clean up your mistakes. There are only so many times I can hit the restart button! You're going to have to be more responsible. Look, I'm sorry . . . it's really not about you, it's about me. Well, it's really about you. But still.

Love,
Your Metabolism

IF YOU ARE UNDER TWENTY-FIVE PLEASE READ THIS

Yo yo yooooooooo! You CRUSHED it last night! Aw dawg, I thought for sure you weren't gonna hang when they brought out the third bowl of all-you-can-eat pasta but SLAM YOU HELD IT IN THERE! You're the best, dude. I love hanging with you. I can't wait to finish this bacon-cheese-bomb burrito. Maybe after we could grab that pizza we dreamt about last night? Perfect breakfast food.

5EVER YOURZ,
M-bizzle

{ PASTAFARIAN }

You may think I'm small, but I
have a universe inside my mind.

—YOKO ONO

Get high. Make pasta.

Cocktail

I don't really like to cross-fade. It makes me dizzy and then I puke. But some
people love it because they say it keeps you from getting a bad hangover
because you stop drinking and start eating. So that's good!

Ingredients

* water
* pasta
* salt
* stuff to put on the pasta

WHAT DID THE YEAST
SAY TO THE FLOUR?

LET'S GET BAKED!

Instructions

Boil water . . . whoa . . . water is amazing . . . look at the way it makes all the
bubbles on the bottom first . . . and then the bubbles get bigger . . . and start to
move . . . wow . . . now there are so many bubbles at the top . . . what's the word
for this? . . . Effervescence . . . that's actually a concept in Buddhism . . . bubbles
on the water . . . ever changing, but always present . . . like the flow of life on
the earth . . . and now the water is overflowing the pot . . . that's amazing . . .
Oh. This is a bad thing. Off.

Life Lesson

I really can't cook when I'm high

because I just zoom in on one thing and stare and think and then nobody gets to eat.

{ SLOPPY JANE }

I'm in bed but my laptop is dying and my charger is in the living room.

—FIRST WORLD PROBLEMS

If you're reading this you are probably an adult who lives in the first world. In fact, I might be so bold as to say that 100 percent of you are currently in or near a structure with electricity and running water. Also possibly WiFi.

And you probably have some sort of thing you're doing, or at the very least varying options for entertainment. Sure, you might be super depressed and living on your parents' couch, but at least there is a couch to live on.

So where does this leave us, with all of our material needs met, and our spiritual/intellectual/stimulative desires able to be pursued to some (no matter how minor) extent? It leaves us with our health and physical appearance . . . and stuff. Personally, I'm not too perturbed by these things (says the hypochondriac who literally has WebMD open researching a cough that won't go away that I dunno maybe it could be something who knows okay it's always good to check), but for those of you who are, I've created this delight.

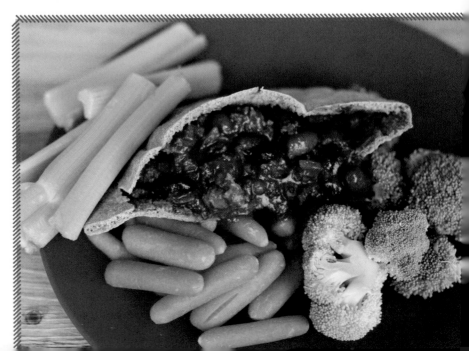

Cocktail

Vodka and gin have the least amount of calories turns out. Wow! Yay!

Ingredients

* a whole wheat pita
* canned turkey chili

* iceberg lettuce
* tomato

Instructions

Lightly toast the whole wheat pita on a skillet. Oops.

Throw away your now burnt pita and instead microwave it or something so it's warm.

Oh, but if you're trying to be healthy I would recommend avoiding micro-waves because WE JUST HAVE NO IDEA OF THE LONG-TERM EFFECTS OF THAT THING YOU KNOW and instead just like . . . eat the pita cold, you'll be fine. Open the turkey chili and pour into the pita. You can also eat that cold. Put iceberg lettuce on the plate too . . . for roughage. Or because you're being healthy and people seem to think that iceberg lettuce is healthy, but really the only thing in it is water, which is probably good since you've been drinking all that vodka/gin.

Take a couple bites and realize cold food is gross. Eat the tomato like an apple and move on. Boom. Health.

Life Lesson

Trust me. You look good.

Try to focus on the things that you do have instead of obsessing over the things you don't.

{ PIZZADILLA }

> A friend is someone who knows all
> about you and still loves you.
>
> —ELBERT HUBBARD

Alternatively, have you ever met that person who has everything going for them, but they can't seem to get their act together? They have the resources, the talent, the opportunities, but none seem to pique enough interest to create a catalyst for change. One of my best friends is like this. Deeply talented and grossly unmotivated. Oscillating between a cyclone of despair and an oddly optimistic persistence in terms of dealing with anyone or anything outside of her own life. It baffled me for so long that she could have so much faith in humanity but none reserved for herself.

Then suddenly her behavior and routine radically changed and she told me she got diagnosed and started taking medicine to help her brain out. It turned out the negativity engulfing her internal workings wasn't related to anything around her, but rather came from the hyperfocus on negativity that would consume her mind. I was shocked! It came out of nowhere!

Just like this dish. It's the SHARKNADO of drunk cooking. An apocalypse of delight.

Cocktail

Beer! Cold beer.

Ingredients

* tortillas
* marinara sauce
* cheese

* tissues for everyone who starts to cry tears of joy when you bring this out to serve

Instructions

Preheat the oven and sit on the kitchen floor staring at the oven. This is so you don't forget that you've preheated the oven. If you've decided to do some drunk cooking using the oven, then it's really important that you basically not ever leave that room where the oven is.

Great! It's preheated, so now it's time to put the pizzas in. WAIT! You need to make a pizza first because you have none in the freezer and that is very sad for you and maybe you should just sit back down on the floor NO DO NOT SIT BACK DOWN. You can do this. Just make the pizza from scratch. And you want to do this in a hurry because you're very hungry and you spent most of your time staring into space while the oven preheated so now you feel a little groggy. What is a pizza anyway? Circle thing with cheese and tomato goo? Done. We can do this.

Put a tortilla on a skillet and slap on some pasta sauce. Add cheese. Now again, but oops, that's too much and just scrape it off with a fork. Now place another tortilla on top. Add another layer of sauce and cheese. Repeat as necessary until you've got a satisfying stack of snack.

Stick those "pizzas" in the oven and cook. Once they level up and achieve "edible" status, take them out of the oven. Oh, be careful of your hand-parts because yeah that's hot. And they are likely oozing molten-cheese-goo. And you've learned your lesson after burning your tongue on all those Hot Pockets earlier today.

After they have sufficiently cooled, grab a butter knife and slice! Remember you're far too drunk to be handling sharp cutlery. Now you effectively have a quesadilla of pizzas and a whole lot of happy, drunkish people.

Life Lesson

Friends are great. Make sure to let them know how much you appreciate them.

I like to do this with various offerings of food. They usually decline, but the gesture is there.

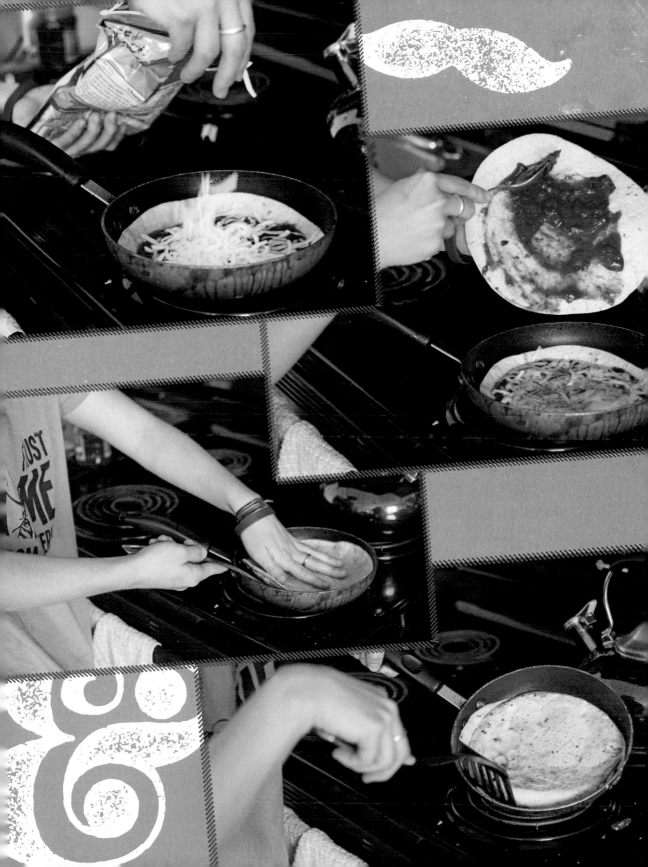

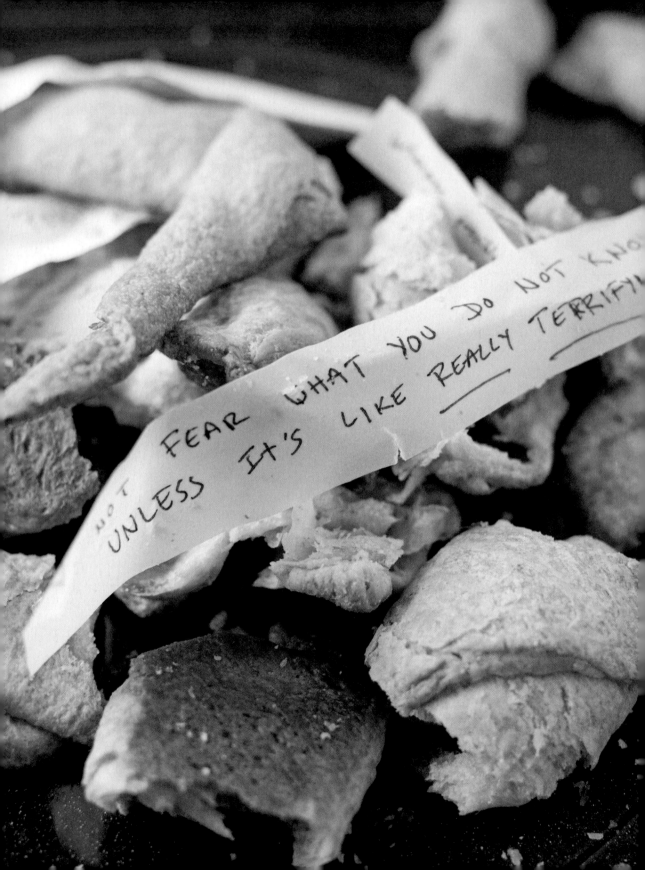

{ FORTUNE ROLLS }

The only person you are
destined to become is the
person you decide to be.

—RALPH WALDO EMERSON

Now, here is a recipe I find to be really helpful when you're hosting a bunch of your friends who seem totally lost on their life path. We're talking the type of people who always think that things happen *to* them and that whatever befalls them is fate and fate alone. I hate that thinking. Personally, I find it much more enticing to believe that destiny and determination are one in the same.

Or is it "one and the same"?

I mean I could Google the answer right now. Since I am typing this on a laptop connected to WiFi. But I'm going to go ahead and let this question linger here. Maybe you will end up Googling it later today and someone will be like, "Huh. What made you think of that?" and then you can say, "I read it in this cookbook I bought and needed to know the answer!" and then they will be like, "Wow! What a funny cookbook, let me go out and buy one for me and all of my friends!" and you'll be like, "Oh! Buy me another copy too! I want one to keep at the office."

Boom. That's predetermined fate, yo.

Cocktail

Calvinist Cocktail. Walk into the kitchen and drink whatever combination
of liquors you currently have in your liquor cabinet.

Ingredients

* pieces of paper
* nontoxic ink
* crescent rolls (because the moon is mega mystical)

Instructions

For this you will need a creative mind and an open heart. This is an excellent dish to be served after a dinner party so that everyone is a touch beyond too tipsy to care that there is a strong possibility that they will accidentally ingest paper.

Step 1: Write inspirational/meaningful/relevant messages to each person at your dinner party.

Step 2: Mix them all together.

Step 3: Follow the instructions on the package of rolls and put pieces of paper inside.

Step 4: Bake.

Step 5: Serve.

If your messages have found their proper owner (or the person you had in mind) then immediately quit your job and start a business as a psychic because GODDAMN THAT'S SOME COOL SHIT YOU JUST DID.

Life Lesson

Destiny maybe isn't just determination, but I'm sure that being open to working hard will help.

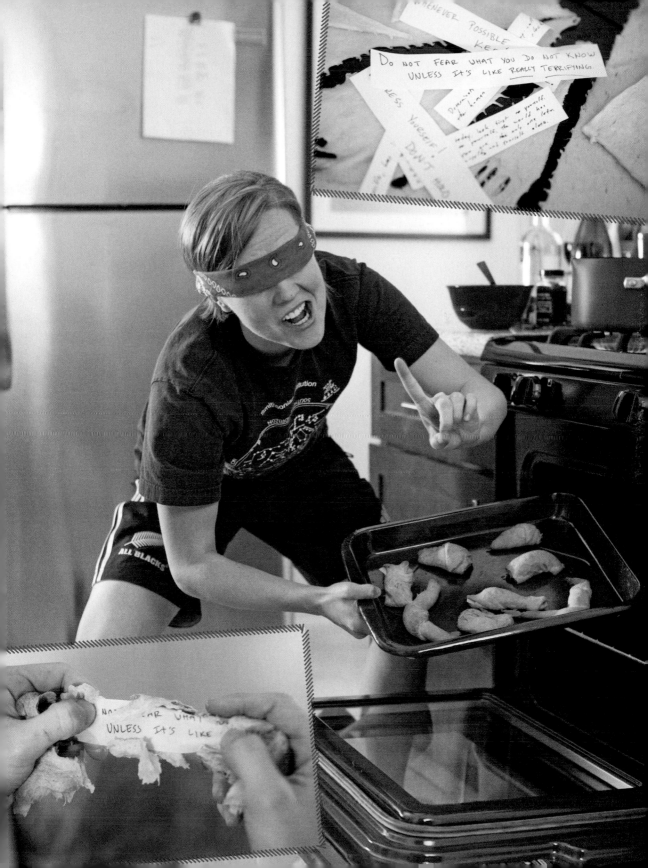

PEOPLE ACTUALLY WATCH SPORTS?

I didn't grow up watching sports. I came from a household that watched "History of the Bible" documentaries on tape and listened to Art Bell's radio show at night. My mother was a big believer in the importance of art and the secret messages encoded in famous masterpieces. Our time as a family was spent doing the one-thousand-piece pointillism puzzles on the floor, finding missing pieces in couch cushions for years to come. Right next to discarded hair ties and oddly greasy pennies.

And I wasn't the type to enjoy playing sports either. I mean, I liked to play games at recess as much as the next kid, but I preferred to be referee. Or to announce each kid as they stepped up to have the next kick during kickball.

I was much more the type to sit at home, go on the Internet, and try to find clips of unreleased *Sailor Moon* episodes from Japan. Is that considered a sport? Definitely not. Let me tell you, when I was a youngster I was pretty far from athletic. We bought my jeans in the boys section of the store and I was so embarrassed to wear them to school because of the HUSKY stitched into the back pocket. But they were loose and comfortable, so there's nothing to complain about there.

Point being that something I have learned in my amateur adulthood is that people *really do watch sports!* Isn't that wild? I mean they really do! And what's more mind-boggling is that now I like to watch sports too!

Well, never alone. Sports are best enjoyed in good company. It doesn't matter so much what team you're rooting for, or even what sport you're watching. The key ingredients to any good game day experience are as follows:

- **Equal energy level:** Have you ever watched something with someone who was a major downer? Like one of those people who asks you to be quiet while you're watching your favorite movie. I'm just trying to keep things interesting by sharing dialogue with the characters! Think of me as director's commentary—live and in person!

- **Excellent SNAX:** I strongly endorse going to your local Trader Joe's and buying all the frozen snackity-snack items you can find. Best part is that when you tell your friends you've "got something in the oven" you can reassure them that it's going to be good

because you didn't make it! But if you really want to bust out the big guns and make something quick you can do Tiny Sandwiches (page 50) or Adult Lunchables (page 111).

If you've got the aforementioned items sorted (plus the obligatory never-ending beer supply) then you're ready to host with the most . . . toast. Ooh, that's a great idea. Toast! Why don't people just serve others platters of toast and small pools of jam and butter? I mean, take a minute to think about that. It would be amazing!

{ NAAN OF YOUR BUSINESS }

I stopped believing in Santa Claus when I was six. Mother took me to see him in a department store and he asked for my autograph.

—SHIRLEY TEMPLE

I'd like to take a moment to very selfishly tell you guys something:

Being famous-ish is weird.

And I know that you probably already think I'm an asshole for saying that, but I don't mean it like, "Oohhh people being nice and liking me suckkkkks." Because that's not at all what I'm trying to say! But like . . . as someone who personally didn't aspire to be in the public eye . . . being in the public eye is weird. Also, it's hard to take criticism and judgment. Also, I'm pretty insecure. And SUPER PARANOID about safety. Like, I check the closets every time I come home. No joke. I really can't help myself. I walk through every room in the house and look behind the shower curtain every single time I enter my apartment. I have since I was a kid! But now I do it because sometimes I get letters sent to my PO box that say "I found you" and it makes it hard to sleep.

So yeah . . . being famous-ish is weird.

Cocktail

Whatever people drink when they sit in a rocking chair with a rifle staring at the front door. That's my shadow spirit animal.

Ingredients

* I have some Indian food left over.
* If I walk backward to the fridge I can get it out.

Instructions

Step 1: Think about that time your mother told you that "fear is another word for intelligence."

Step 2: Pour yourself a glass of wine and watch TV. Try to relax.

Step 3: Make sure the back door is locked just in case though.

Step 4: Forgive yourself for checking the back door for the fourth time tonight.

Life Lesson

It's not a bad thing to be aware of your surroundings.

But be careful to avoid living in a state of hypervigilance. Maybe it's okay to assume that everything is going to work out for the best because lately it really has been. Maybe there's sanctuary in that.

Also, Indian food is one of those meals that tastes just as good, if not better, the second time around. So go ahead and order it again even though you're not done eating the leftovers.

{ ENCURRYGEMENT CURRY }

All we have to decide is what to
do with the time that is given us.
—J. R. R. TOLKIEN

But what happens when you feel like you're on track with your destiny? And there's no longer anything to feel conflict over because for all intents and purposes this is all you've ever wanted and you should be happy?

You see, sometimes stability can be uninspiring. Once your life reaches a certain state of predictability, it can be tough to get motivated to start something new. Or challenge yourself. Or create a higher standard for behavior. Or even get out of bed. Or off the table.

Cocktail

EncourageMINT Julep. *(Yes, I am milking this pun for all it's worth.)*

Ingredients

* basmati rice
* a box of premade curry (preferably the kind that comes in those sealed silver bags that look like you're about to go into space)
* a goal/reminder for yourself (must prepare separately)

Instructions

First bring water to a boil and make your rice. Or reheat rice left over from a prior meal or recipe. Depends on what you have at your disposal.

Next you will need to remove the curry from the bag and then you'll write your inspiring message on a piece of paper that you are comfortable accidentally eating. The best way to get the curry out is to cut a corner off the bag and squeeze the curry onto the rice as if you were icing a cake and for some unknown reason had decided to make your own frosting from scratch in a ziplock bag. You will not find that recipe here.

Once you have written your inspiring message, you must become one with the meaning behind the words. The best way to do this is to eat it. Then let its meaning sink into your stomach acid and absorb its way through your bloodstream and into your heart.

 Life Lesson

Sometimes you need a little bit of stimulation of the senses to put the spice back in your step.

Don't let it get you down. It's only cumin nature.

PRO TIP: The cardinal rule of rice making is two parts water to one part rice. But what they don't tell you is that you're going to need at least three times the patience/planning because nothing kills your ambitious meal-making plans faster than the fact that rice takes 5EVER to make.

{ ADULT LUNCHABLES }

Yesterday I was clever, so I wanted to change the world.
Today I am wise, so I am changing myself.

—RUMI

So! As you may or may not remember, Lunchables are one of the most perfect forms of portable food. Better than a Hot Pocket, a Lunchables meal requires absolutely nothing outside of itself to fully function in the world. Shouldn't we all aspire to be so self-sufficient?

Cocktail

Grape Drink. Pronounced "Grape Drank." (To make this, just add club soda to grape schnapps and serve over ice.) Pucker up.

Ingredients

* cracker-ass crackers
* assorted tiny cheeses
* or cheese slices
* fancy adult salami
 (that's my porn name)
* maybe a pimento olive or
 something classy to show that
 you're a grown-up now

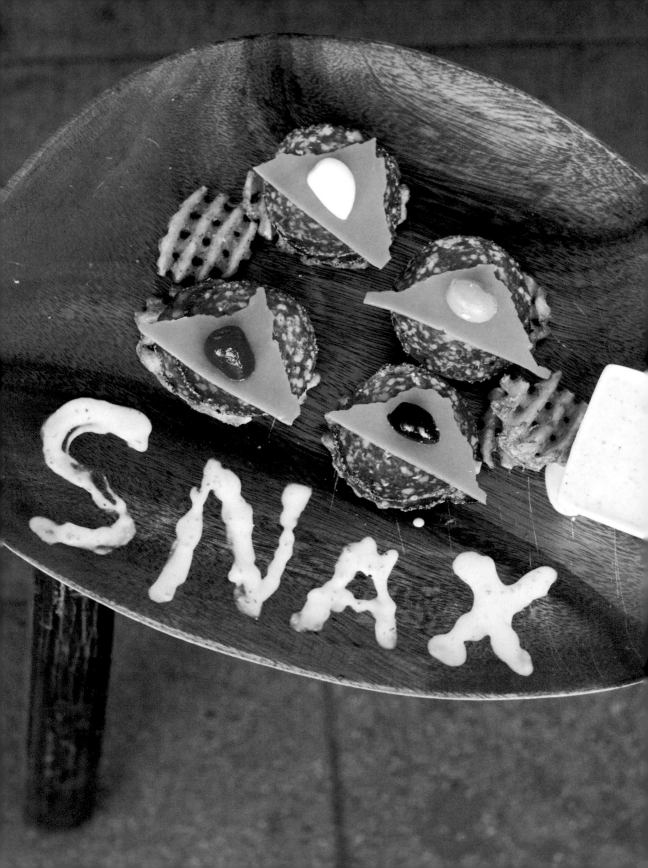

Instructions

The first step is to drink your Grape Drink.

Then proceed to place crackers in a neat little stack. Feel free to munch on them as you go, but make sure not to just eat all the crackers at once because then you will have no crackers left for your plate. Oh, but this might be a really good time to practice eating six saltines in sixty seconds. I've never been able to do that, but maybe you can. Who knows. This could be your moment.

Then proceed to pull out your deli meats and also place them into a neat little stack. Also, feel free to eat some as you go, but make sure not to just eat all the meats at once because then you will have no meats left for your plate. Oh, but this might be a really good time to practice eating six salami slices in sixty seconds. Wow. That was easy. No wonder it's not a party game.

Repeat the process with cheese. Oh wait, don't. Aw man. Now all the cheese is gone. It's impossible to show restraint with that little dairy-based she-devil.

Life Lesson

The key to being self-sufficient is abandoning desire. That's what Buddhists say ends all suffering for the human heart. First, one must let go of external desires to achieve internal peace.

You must keep this in mind when preparing your adult Lunchables plate.

Congratulations! You now know how to be a fully formed, flaw-free, fit, and functional . . . ADULT! Well, not really. But maybe you're a couple steps closer. Again, let's recap. Just in case you want to rip out this page for a handy reminder of the things you're working on:

- **Tiny Sandwiches**
 (Size doesn't matter! Aim to satisfy.)
- **Saltine Nachos**
 (It's not about resources! It's about being resourceful.)
- **Frito Taquitos**
 (Go with impulses from time to time!)
- **Jewish Taquitos?**
 (Giving up is a guaranteed failure.)
- **Pizza Pie Chart**
 (Everyone is different! Judge in moderation.)
- **Pizza Cake**
 (But seriously though. Delicious.)
- **Hot Rods**
 (Try new things! Just not drugs!)
- **Crunchy Roll**
 (Wealth does not define happiness.)

- **Dick-Taters**
 (Practice patience in political debate.)
- **Macaroni and Peace**
 (Don't lose momentum in discussion! Try out a new idea privately first!)
- **Sweet Dip**
 (Be nice . . . but not in an "I'm a martyr!" way . . .)
- **Hashtag**
 (Don't be an angry drinker.)
- **The Saddest Cake Ever**
 (Don't diet. Rethink your lifestyle.)
- **Pastafarian**
 (. . . but have you ever really *looked* at a bird?)
- **Sloppy Jane**
 (Focus on your positive traits instead of your negative ones!)
- **Pizzadilla**
 (Appreciate your friends!)

- **Fortune Rolls**
 (Determine your
 destiny!)
- **Naan of Your Business**
 (Healthy boundaries to
 support self!)

- **Encurrygement Curry**
 (Stimulate to motivate!)
- **Adult Lunchables**
 (Aim for self-sufficiency!
 Maintain friendships out
 of want instead of need.)

I'd actually like to talk about that last one for a moment longer. The concept of self-sufficiency. You see, I feel it's important to know that you can be comfortable while being alone. But that doesn't mean you have to seek isolation! Rather that the essentials for your own emotional survival are something that you can carry with you in your heart. As opposed to having them met by someone whose role in your life may only be temporary.

That's why I'd also like to share some closing recipes on the importance of cooking for one.

Eating Alone:
?? Why Am I Always ??

(Meals portioned for one person to eat while standing over the sink)

I sort of hate being alone. But I also kind of love it? It's a mixed bag, really. On one hand, being alone gives you time and space to think. On the other, you end up feeling like an experience is a little empty because there is no one to share it with. I used to really hate seeing people eating alone at restaurants, or I would avoid cooking a meal because I knew I was going to make too much and then there would be leftovers that would go bad in the fridge.

Or at least that's the way I *used to* feel!

{ HUEVO RANCHERO }

Because two is too many and one is never enough.

Cocktail

Bloody Mary, because it's morning time. But make it spicy.
Ooh, and use tequila maybe? Is that called a Bloody Maria?

Ingredients

* corn tortilla
* black beans
* egg
* diced onions, tomatoes, etc.
* queso
* hot sauce

Instructions

Make huevos rancheros but do it in the singular instead of the plural.

Life Lesson

This goes really well with Guaca-hole-y. See following page.

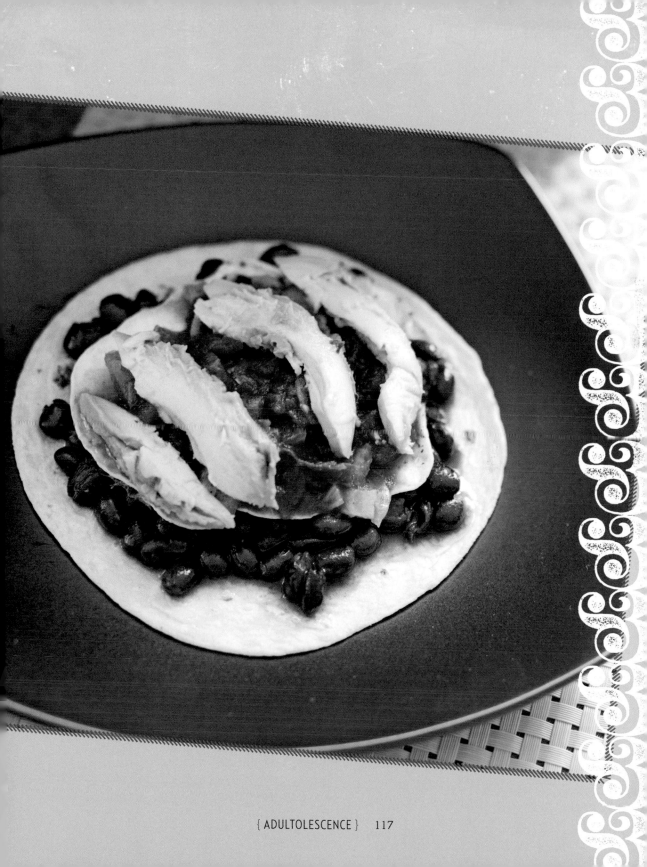

{ GUACA-HOLE-Y }

How to make a single serving of guac inside half of an avocado!

Cocktail

Sippin' on that one bottle of tequila you keep in your fridge.

Ingredients

* avocado
* salsa
* that's it!

Instructions

This is actually a really great move for the times you find yourself interested in having guacamole, but unable to commit to having an entire batch of guac in your fridge. You know how sometimes it gets all brown and old looking after a couple days? Yeah, nobody wants that. And realistically, you're not gonna be able to eat that all at once. And right now you don't want to take the time to dice some onions and let them soak for ten minutes in fresh-squeezed lime juice as the base. That's my trick. Shh. Don't tell anybody. Now you know though. But that's okay, because I trust you. We trust each other.

So, slice an avocado in half using a butter knife. If a butter knife isn't enough to slice the avocado then DON'T EAT THAT AVOCADO! Many a time people try to make guac with an avocado that is no-where near maximum ripeness. That's *no bueno*.

Now, take the avocado pit and put it in the garbage. Or draw a face on it. Or put it in a jar with water and watch it germinate. Some people

use avocado pits as a diuretic in smoothies. Isn't that disgusting? Humans are weirdos.

Take a spoon and scoop some salsa into the empty space where the pit once was. Now mush it all up within the avocado skin.

Perfect. Amazing. Add a little lime/salt/pepper/chili/whatevz and eat that while standing in the kitchen.

Life Lesson

Sometimes being alone is okay. One time I got lonely and then got drunk and then made a video for the Internet. It didn't turn out to be so bad.

that looks nasty

SO THIS IS LOVE

Recipes for Relationships

Hey girl.

Or guy.

Or whatever gender pronoun floats your boat.

Let's talk about love, sex, and dating. The human heart is a complicated place. Also, sometimes needy and attention seeking. Or repressed and desensitized. Or clouded and jaded. Or optimistic and peaceful. Experienced. Naive. These are all adjectives that mean things in the context of describing words in what we call a "language." Know what I mean? Good, because I don't really have a sense of where this is going exactly. Just that I'm kind of skirting around the issue. Which is very much what happens to people sometimes when they try to discuss relationships.

You see, like it or not, you're going to have to interact with other humans. It's because we are pack animals. Life is like one big nature documentary and as far as I'm concerned, if you're not currently being eaten by a lion, you're doing a great job.

Who Loves You?

But sometimes, for some reason, somehow entirely outside of your control, you find yourself slowly falling in love with another sack of cognizant human meat flesh.

Everybody drink!

In this section of the book, you will find yourself privy to my limited personal insights regarding the arena of love. Now, to be fair, I have very little experience because I run from relationships like a person who enjoys running. (Except that I don't actually enjoy running at all. And I don't understand people who do. But to each their own!)

In my mind, a relationship between two people and its lasting effect on their lives can best be likened to the experience of eating a meal. For instance, sometimes you decide to try something new, like Ethiopian food, and maybe you like it, maybe you don't, but at least you tried.

Sometimes you eat something you order a lot, but just when you least expect it you discover that this thing you have all the time has suddenly made you very ill. That's like food poisoning of the heart and it can last for a very long time if you let it.

To make this more clear, let me describe my only three experiences with love (significant love, not just sex, not spooning your best friend, not falling in love with a fictional character, etc.) as if they were parts of a meal:

1 FIRST COURSE: Appetizer

A small dish of food or a drink taken before a meal to stimulate one's appetite

I was about nineteen when I fell in love for the first time. It was with a classmate of mine who was also studying Japanese literature. She was Japanese, in fact. Oh, she was also a she. A fact that disturbed me no end, because I had spent the majority of my life crushing that sort of thought into a dense ball of repression about the size of a balled-up Britney Spears poster that I most certainly didn't buy because I thought she looked really pretty and it made me feel nice to look at. Anyway, back to the love story.

She and I were friends for a very short period of time before making out in my bed one night after I had confessed to her my very confusing and muddled feelings. I believe the exact phrasing was "Being near you makes me feel happy. But being that happy, *so happy* . . . well, that makes me feel sad. But then not being near you makes

me feel sad too. So I don't know which sad I want . . . the sad from missing your company . . . or the sad from having you around."

I mean, how could you not kiss me after that bucket of nonsense?

Our relationship was very sweet and very much "first love." There were many awkward moments, melodramatics, neglected friendships, and all that comes with falling into that obsessive pit of devotion that happens when you find someone who you want to tell everything to. Especially when you want to tell them everything while you have your mouth on their mouth and it feels so nice.

We dated for six months before I left the country to study abroad in Japan. She was a mess before I left, saying that "it would never be the same" and "what would she do now" and "what's next" and all the sentences that would make someone with experience in a healthy relationship do a double take. But I was so blissfully closeted and lovesick that I didn't question the strength of our devotion to each other for one minute. Because this was the one girl, the *only* girl, that I was ever going to love.

Two weeks after I left, I found out (via incredible amounts of Facebook stalking) that she had slept with one of the male RAs in her building. I called her in the middle of the night a total train wreck—alone in the countryside in a country where no one spoke a language I could understand—asking her to explain how she could cheat on me so soon after I had left.

Her reply was a question

"We were in a relationship?"

So, as you can tell, the first time I fell in love it was a pretty jarring experience. It left me pickled, in fact. *Tsukemono mitai.*

2 SECOND COURSE: Entrée

The main course of a meal, or the right to enter or join a particular sphere or group

Watching your first love exclusively date the opposite sex for the remaining years you shared classes in college can leave a closeted homo feeling pretty shitty about themselves. Also, with enough trust issues to start a magazine fund! (Trust . . . fund? Issues . . . magazine? Anybody? Bueller?) So, after I was dumped I desperately tried to

make myself love men again and just found that it was like kissing your brother. (Not that I've done that. I mean your brother is a nice guy, I'm sure . . . but no thanks.) Basically, I felt that the world had done me a great disservice by having me fall in love with someone who didn't want to love me forever like I wanted to love them forever. I felt that this occurrence was very unique and no one could ever, *would* ever, understand the level of heartache I was currently enduring.

But obviously as time passed, and I healed, I realized that maybe I could love again, but I had to know for sure that they were going to be the one, so that meant dating a "real" lesbian, who for sure was never going to cheat on me with some dude while I was away! Needless to say, this was not a foundation strong enough to build a healthy relationship on.

Now this was one of those situations where you find yourself dating a person for over a year when you knew two months in that it wasn't going to end well. But being young and only recently introduced to the joys of sex with someone you're genetically predisposed to find attractive . . . well, you'll put up with a lot for a long time. And for me, I put up with it for as long as I could stand to have such amazing sex.

But there comes a point in any relationship when one party simply doesn't enjoy the company of the other and it just can no longer be ignored. For me, this point happened twice. The first time was when I tried to break up with her before we left for a trip to Paris together—a trip that I ultimately went on anyway and deeply regretted, as it kept our relationship going for another four months. The second time, I finally succeeded in breaking up with her, but that ended in her seeking some serious mental health assistance. And I felt pretty terrible about it. But maybe happy because she's hopefully doing a lot better now? She was lovely! But we really just weren't right for each other. Can you guys tell that I still feel slightly guilty? I can. Oy.

Anyway, point being, by the end of this relationship I had given up any denial over who I was. I was a person who loved girls, because I would date someone who I couldn't stand for a year because I loved to have very gay, gay, gay, gay sex with her. And that's okay. People are shallow sometimes. In the end, at least, I'm not in the closet anymore.

And because I didn't finish eating my entrée I had plenty of room for . . .

3 THIRD COURSE: Dessert

A sweet course served at the end of a meal

It's important to start this off by saying . . . I don't really like sweets.

I never really have. Probably something to do with gorging myself on cheap food as a child (candies, dollar menus, etc.), but as an adult I just don't like sweets. I don't crave them. They are not "must haves" for me. I don't drink soda. And frankly, it feels more like obligation than indulgence when I do dabble in desserts.

So, I can honestly say that I never expected to find myself so deeply in love with someone who can't get enough of Funfetti cake.

Now, after that last relationship ended, I didn't *really date anyone for four years.* Four years! Four years is a long time. Especially when you're rockin' this sweet bod! (Not pictured: sweet bod.)

But it's true: four years. No dating. I took a long hiatus from hearts in general. I just didn't want to make myself vulnerable to heartache again. Nor did I want to hurt someone else whose only fault was that they fell in love with me. It just seemed like a messy and unpleasant prospect. So, instead of seeking out a companion (which up until then had been my one and only goal: I'm very simple. I honestly just want a wife and kids and a backyard for a puppy), I decided to focus on building a life with my career instead.

And they say that's when it happens. That when you stop looking for love, then love will find you.

But if that doesn't work then there is always online dating.

So that's basically what I know about love at this point in my life. I feel like the people we find ourselves drawn to are somehow reflections of the love we were given (or denied) as children. And this could manifest as unconditional loyalty or devotion to people who don't necessarily classify as healthy and/or functional human beings. But more often than not, they don't know that about themselves, so how should I!

Before I let you go to read those recipes with my tips and tricks on trying (or crying) while in love, here is one helpful tool to identify if you/your loved one are loving correctly or at least semi-decently: love people for who they are, not who you want them to be. (Yourself included.)

Meaning, if you find yourself continually disappointed or drowning in excuses for

erratic or unchanging behavior, then just get out! Life is too short to waste on trying to fix somebody you can't fix.

HOWEVER: Such actions should only really be taken if you know that you are communicating your needs properly. You can't accuse someone of "not trying hard enough" if you haven't given them a clue as to what exactly you want them to be trying for.

HOWEVER-2: Be careful that you're not blaming someone for your actions too. You've got to take proper care of yourself before you can ever hope to take care of a relationship that matters.

HOWEVER-3: Understanding another takes time. So does bonding when you don't feel comfortable with attachment. Try combining your names on party invites or buying embroidered vanity towels with your names on them. Oh! Also say "we" a lot. People love that.

Anyway, take the following section with a rice-size grain of salt. Remember: I have no idea what I am talking about when it comes to cooking. So why would I know anything about love? Or, frankly, the experience of any life outside of my own?

But I can imagine what it *might* be like.

And I can try to understand.

And that's really all this book is doing anyway.

THAT'S ME!

{ CRUDE-ITÉS }

It is your work in life that is the ultimate seduction.

—PICASSO

Here we begin our exploration of love by teaching you how to impress potential mates.

If you've been courting a person for a while, but they still don't seem to be getting the message that you're ready to get down, try sending a signal through the art of crudités.

Now, you might be wondering, what exactly are crudités? Well, it's the most boring appetizer known to man. It's basically just thinly sliced raw vegetables. SNOOZE ALERT.

But what if you made them sexy as shit?

Cocktail

Whatever their favorite is. Because remember, this is about seduction.

Ingredients

Go to your local farmers' market and handpick the freshest organic ~~ingredients~~ JKJKJKJKJK. You're going to be using this food for what purpose? Making provocative images on plates? Puhleeze. Just grab yourself something from the corner store and get to work. There is art to be made! Here are some of my personal recommendations:

* carrots
* celery
* berries
* citrus fruits
* apples
* fuck it, anything really, this is your palette

WHAT DO YOU CALL a CUP OF EARL GREY THAT'S BEING SEXY?

A TEASE!

Instructions

Now you're ready to get it, girl (grrl?) (TIGER STYLE).

Life Lesson

 # Or maybe they are just hungry and you should take them out to dinner?

They do work full-time and you're one of those creative stay-at-home types who thinks that building IKEA furniture all by yourself qualifies as a day well spent.

{ STRING (CHEESE) THEORY }

I stopped looking for a Dream Girl, I just wanted one that wasn't a nightmare.

—CHARLES BUKOWSKI

But you aren't the only one trying your hand at the love game! Your friends are starting to date potential life mates too.

. . . but why do our friends sometimes date people who suck? Like we all have that one friend in the friend group who just keeps bringing around the same type of wrong. Somebody who doesn't get the jokes, doesn't like the right music, has no life goals . . . the list goes on! But somehow this type of person keeps dating your dearest bud. (I actually think I'm that friend in my friend group . . . but I can see both sides!)

But then if they are *actually* your friends, why would they date someone who *sucks*? And if your friends suck . . . well, could that imply that you, yourself . . . might suck?

No, that is absolutely untrue. You do not suck. In fact, you rock.

Appearances are only skin deep, so the best way to determine if this interloper is down for a chill hang is to offer them a perfectly viable option for hosting a snack.

Cocktail

A chill beer. Because you're having a chill hang.

Ingredients

* string cheese

Instructions

Put some string cheese on a plate and proudly announce to the room, "I made snacks!" If the individual in question declines your offer of perfectly acceptable string cheese . . . then kindly ask them to GTFO.

Life Lesson

It's hard when your friend dates someone who sucks. But the truth is that you don't know the full extent of their relationship. I say offer your honest opinion of them! But keep an open heart. Sooner or later they will figure out what's best for them.

Unless you are in a romantic comedy, because maybe then you are secretly in love with your BFF and OMG that's my favorite sort of movie ever.

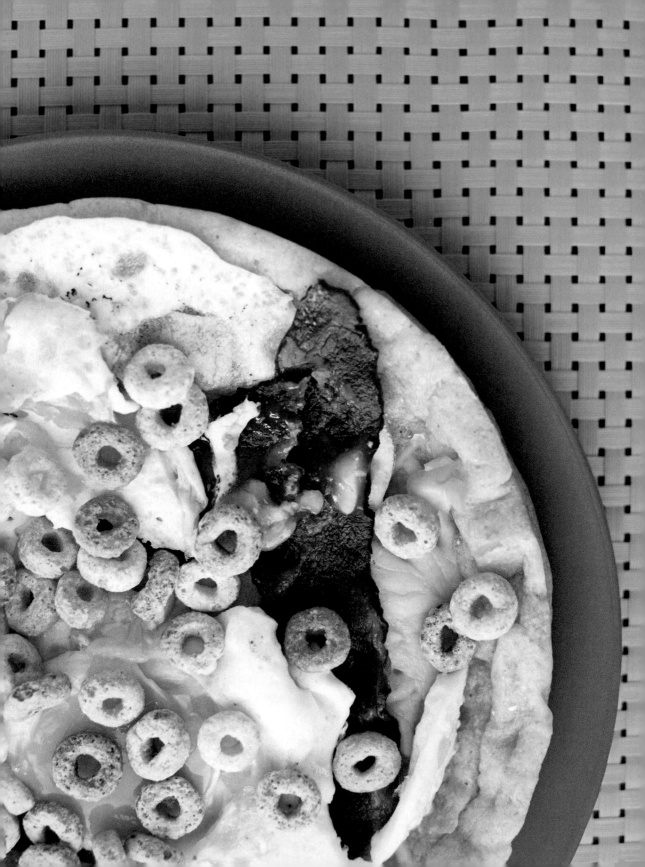

{ BREAKFAST PIZZA }

You know you're in love when you can't fall asleep because reality is finally better than your dreams.

—DR. SEUSS

Here we return to *your* journey of love, because like I said, this is a book about *you*.

Now, let's say that your Crude-ités (page 129) worked and that friend turned into the dating buddy you've always wanted! And it's so happy! Because you are in the beginning stages of love where everything is so beautiful and easy!

Something I enjoy most about being in the honeymoon of love is waking up in the morning and jumping out of bed to cook my honey something special.

The following recipe is indeed . . . very "special."

Cocktail

The Perfect Mimosa. Because you're in love and everything is perfect.

Ingredients

* pizza!
* eggs!
* bacon!
* cereal!
* who cares, you're in love!

WHERE DO BUNNIES GO FOR BREAKFAST?

I HOP!!

Instructions

Unwrap yourself from that warm and comforting embrace and tiptoe on the fairy clouds that line your hallway. Oh look! Your kitchen is a mess from the meal you cooked together last night! How adorable and wonderful. Just use an envelope from some unpaid bills to wipe things up.

Take a frozen pizza from the fridge and put it in the oven. Oh my goodness, but wait! That is not enough for your precious angel to eat this morning. You should also make some eggs. Add them too. But what about protein? There isn't enough to sustain a lifetime of cuddles! Better fry up some bacon. Oh wait again!!! But the angel loves sweet things! Garnish with Froot Loops for some extra sugar kisses.

Prance back into the bedroom and feed delicately. Cherish every moment as if you were the morning dew vanishing upon the petals of a blooming rose.

Life Lesson

You're in love, you're in love, and you don't care who knows it!

Also maybe only eat vegetables for lunch and dinner.

{ QUICHES IN SCOOPS }

Brunch is where people go to
complain about problems that aren't
really problems.

—MY DRUNK KITCHEN, EPISODE 6, "BRUNCH"

But sometimes love is not like that at all.

As I mentioned before, I have a tendency to always end up babysitting/taking care of the person I'm dating. Even after I've ceased to enjoy their company! It's just a bad habit that stems from childhood I'm sure.

One time I was caught in this cycle and I was dating someone who was constantly complaining that we didn't go out to brunch enough. Right. Like that's a real issue.

Anyway, here was my handy solution!

Cocktail

Secret sips! This is what I call it when I go to the freezer and take a swig of whatever sort of flavored alcohol I have on hand. Best to use a flavored liquor that leaves less of a trace on your breath. The scent of hard liquor in the morning sometimes sends people the wrong message. Like that you're secretly drinking behind their back because you don't really like them. Imagine that!

Ingredients

* scrambled eggs
* scoops
 (like those ones that Tostitos makes?)

WHAT DO YOU CALL THE PART OF YOUR BRAIN
THAT'S GOOD AT MAKING OMELETS?

SPATULA OBLONGATA!

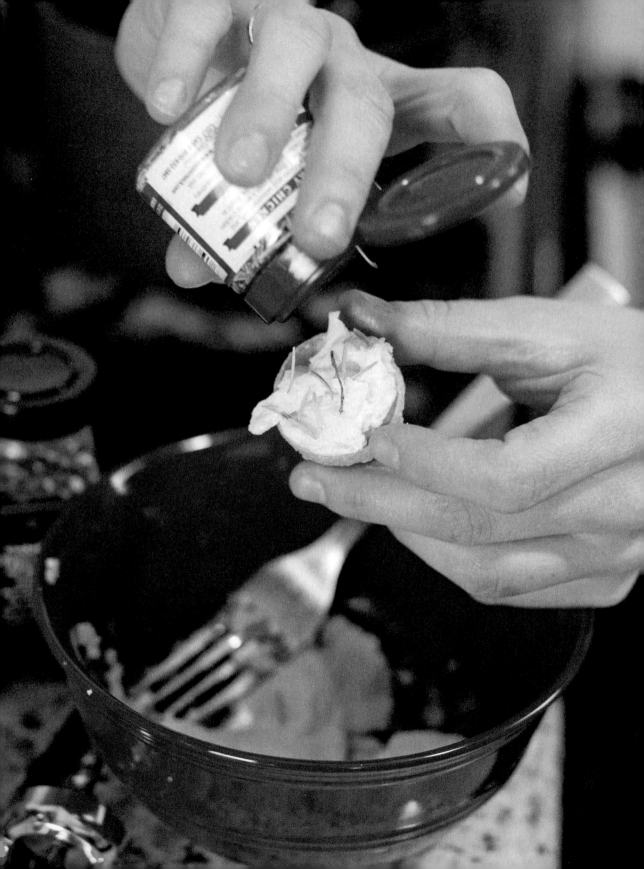

Instructions

At this point in your adult life, you should probably know how to make scrambled eggs.

If you don't, here is how you do it:

Step 1: Try to make an omelet.
Step 2: Give up.

Great! Now you have a scramble. Take that scramble and scoop it up with scoops. Then put those scoops on a plate and bring to the person in question. If they ask you what this is, just say, "Brunch, bitch," and drop whatever mic you were holding.

Life Lesson

Don't do something like the aforementioned recipe!

There's no need to be so passive and reactionary. You can be proactive in all elements of your life. For instance, if you know that you don't like scrambles, then stop making them. Just take the time for yourself to learn how to make that omelet you've been waiting for.

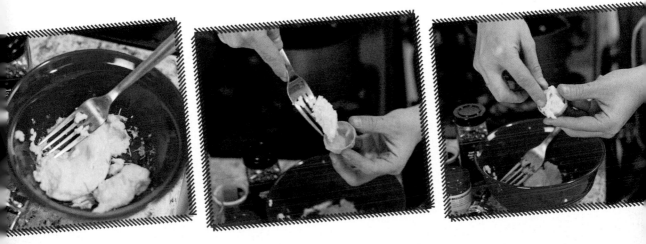

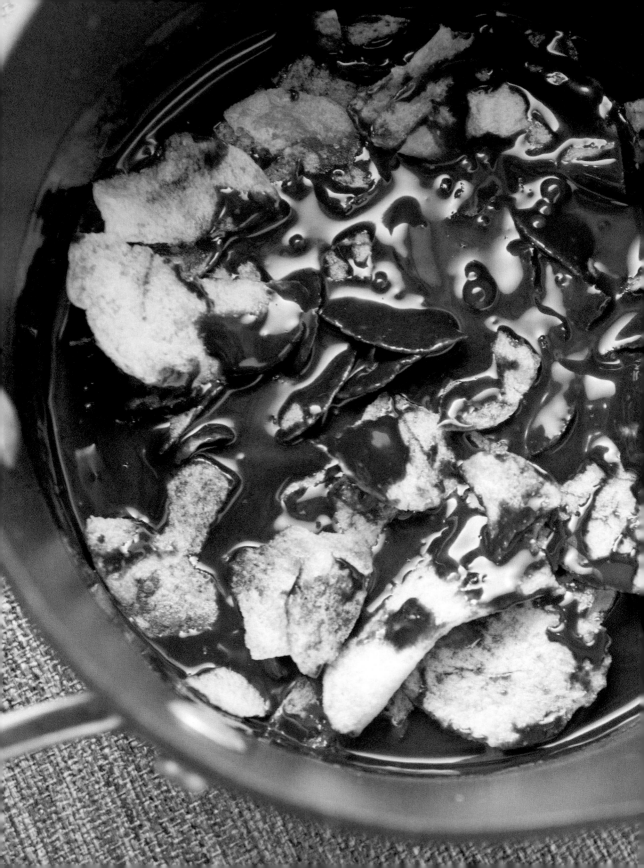

{ CHOCOLATE CHIPZ }

The heart has its reasons which reason knows not.

—BLAISE PASCAL

At this point you may be wondering, "But Hannah, how do I even know if I am in a good relationship? We don't seem to share any common interests!" Fear not.

I've always gone after tortured creative types. I figured that if I was going to lie awake at night, or drink too much, or slowly self-destruct . . . well, I might as well date someone who does the same. Misery loves company and whatnot.

But one time I dated an emotionally stable, relatively happy and ambitious WASP, whose parents are still together and who was more concerned with business than art, and I was shocked by how . . . compatible we ended up being. Seriously. Who knew that someone who watched *Real Housewives* could be such a real deal?

So! Sometimes a good pairing is about bringing two opposing forces to the table. The reason for this is that the experience of the one will serve to enhance and heighten the sensation of the other. This is true for all things except political debate with aging family members. However, the marriage of salty and sweet is an excellent example of such an occurrence.

Cocktail

Red wine. Because you're doing something divine.

Ingredients

* a thick-cut, ridged potato chip (not pictured)
* chocolate for melting

Instructions

DO NOT DOUBLE-BOIL CHOCOLATE. This is time consuming and confusing. Instead just put the chocolate into a microwave-safe bowl in the microwave and stir every . . . um . . . thirty seconds or something? Wait. That's way too long. Start out every ten? Okay, just get a new bowl and figure it out.

Then dip your potato chips in the chocolate! Let them cool. Be careful of your mouth. Also be careful of your fingers. Or as my friend Grace likes to call them, your "Jesus combs."

Life Lesson

When you know, you know.

WHAT TO COOK ON YOUR FIRST DATE

A recipe that you've perfected. Something complicated-ish. Classy-ish. And not too filling, because you're definitely gonna get a kiss-kiss after.

My recommendation?

Salmon filet sautéed in garlic butter with brown rice and broccoli.

Dessert?

Mochi green tea ice cream. Blammo. You've got a theme.

WHAT TO COOK SIX MONTHS IN

A recipe that you can make together. Something lighthearted, fun, but semi-indulgent. Because isn't it so great that you're in love? Love in its youngest and most sincere form? It's not that they are perfect, but maybe they are perfect for you.

My recommendation?

Shake 'N Bake chicken with veggies and mashed potatoes.

Dessert?

Two spoons, one pint of ice cream. Best eaten while standing in the kitchen. Bites best taken between bursts of shared laughter.

WHAT TO COOK TWO YEARS IN

A recipe that is familiar and safe, but leaves you questioning whether or not this is the best choice you could have made.

My recommendation?

Spaghetti and meatballs. But hey, maybe you could make the meatballs from scratch? Yeah, you're pretty tired too . . . sure . . . maybe it is best just to order pizza.

Dessert?

Might skip it. Feeling like it might be good to cut back.

WHAT TO COOK TO SPICE UP YOUR MARRIAGE AND HOPEFULLY GET YOUR WIFE TO SLEEP WITH YOU

A recipe that shows that you're on the same page. It's substantial and satisfying. But that doesn't mean it couldn't use a little flare from time to time. A new spin on an old favorite.

My recommendation?

Rollplay (page 155)

Dessert?

Crème brûlée. Remember that cooking blowtorch you bought after all those episodes of *Top Chef*? You never tried that. You know what else you've never tried? Bondage.

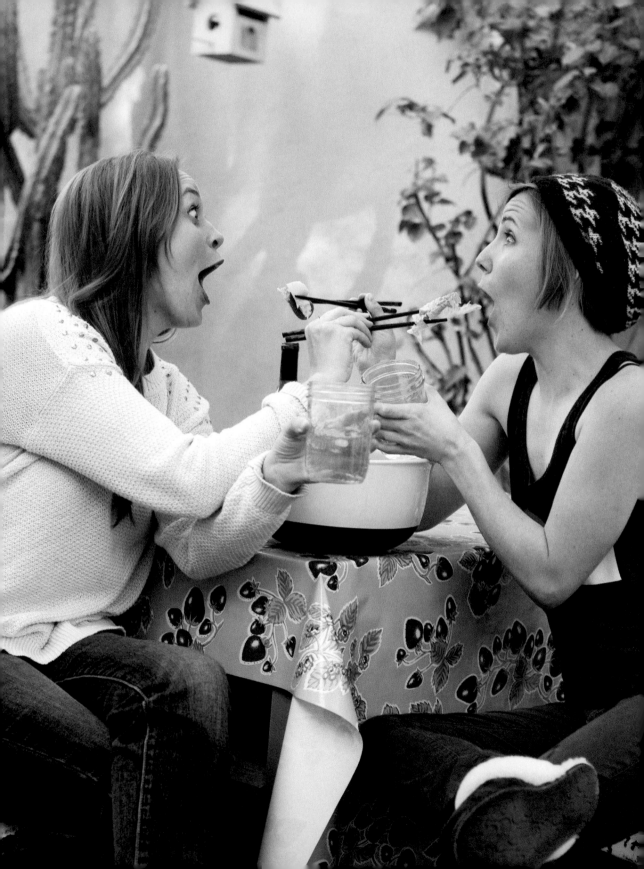

{ HEART-BEET SALAD }

I came up with this recipe.

—MAMRIE (*Pictured Opposite*), After She Reads This Book

A summer delight! This salad is a great way to beet the heat. But remember, the best way to get to someone's heart is through their stomach. So be sure to wash the lettuce so you don't accidentally give them food poisoning.

Make sure to serve outdoors while laughing hysterically. Because aren't salads so fun? Women love salads!

Cocktail

A nice chilled white wine goes well with this delight.

Ingredients

* lettuce (bagged and prewashed, so you can save time to think of clever things to say)
* artichoke hearts (jarred)
* beets (canned I guess? But be warned because those are super gross so maybe just grab some from the salad bar at the grocery store?)

Instructions

Rip the bag open and let the lettuce fly everywhere. Just kidding! Aren't salads fun?

Next the artichokes . . . but who do you think you are? Runnin' round leaving scars . . . tearing love apart? Collecting your jar of ARTICHOKE HEARTS? GET IT? Hahaha! Oh my goodness you're so hilarious and this salad is so fun!

Now beet it. OH I JUST CAN'T STOP!

Toss that salad. But pour them a drink first and make sure they are into it. If so, pour yourself a drink and see if you're into it. I'm not. But you do youuuuu! Serve.

Life Lesson

It's basically just artichoke hearts and beets in a salad, so be sure to serve this to somebody who will appreciate what a gifted punner you are.

Remember, personality first. Then look for trust funds.

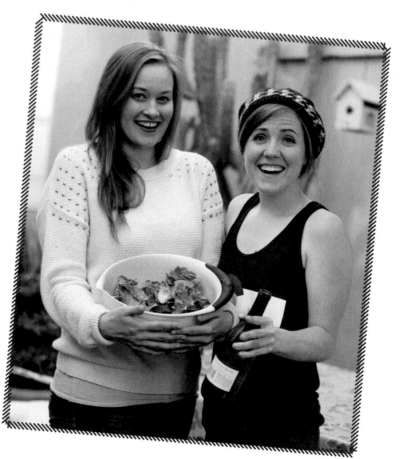

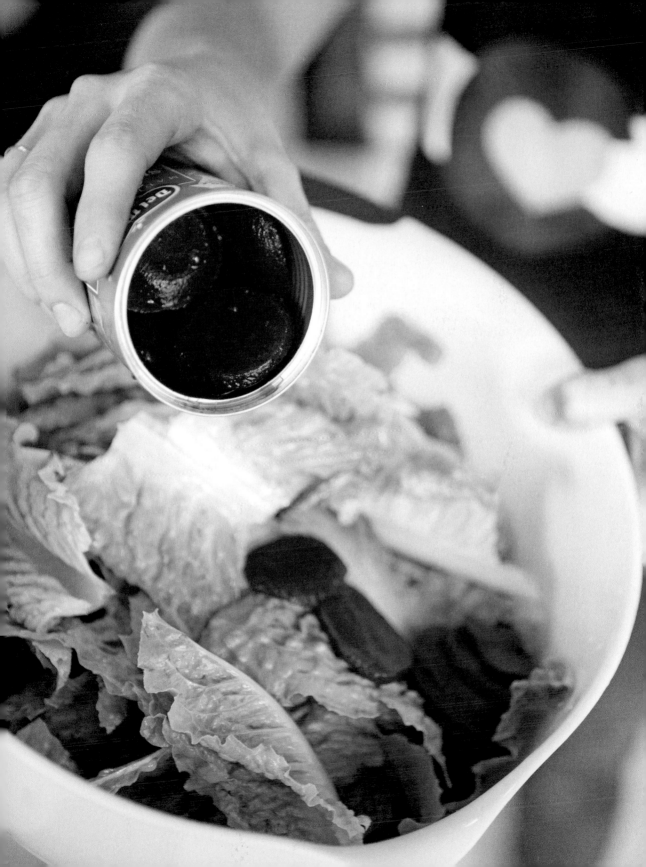

{ CA-PRAY-ZAY }

If you want romance, fuck a journalist.

—W. H. AUDEN

Now, let's take a break from all that touchy-feely stuff and get sexy! And what could be sexier than talking about Italian appetizers?

A caprese salad is actually one of my favorite things of all time ever. If you've never had it, let me paint you a picture of pure salivary delight:

- thick cuts of heirloom tomato, plump and full of want;
- buffalo mozzarella so wet and fresh it's all you can do to keep it from slipping through your fingers;
- ready and willing basil that fills the room with its scent;
- and the barest drizzle of balsamic vinaigrette, trapping the contents to the plate like the lace of a tightened bodice.

Cocktail

Put the infidel in . . . Zinfandel.

Ingredients

Don't think. Don't blink. Just enter the boundaries of carnal pleasure.

Life Lesson

Don't leave me alone with the appetizers?

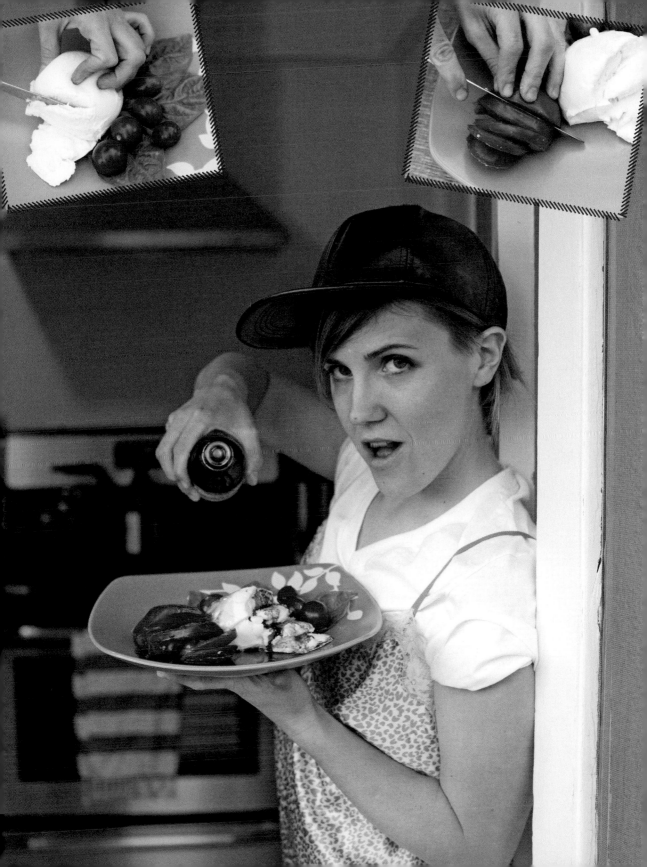

{ CORN STAR }

I remember the first time I had sex—I kept the receipt.

—GROUCHO MARX

This is where you'll find your favorite hard-core corn. Yeah, girl.

Corn on the Cob

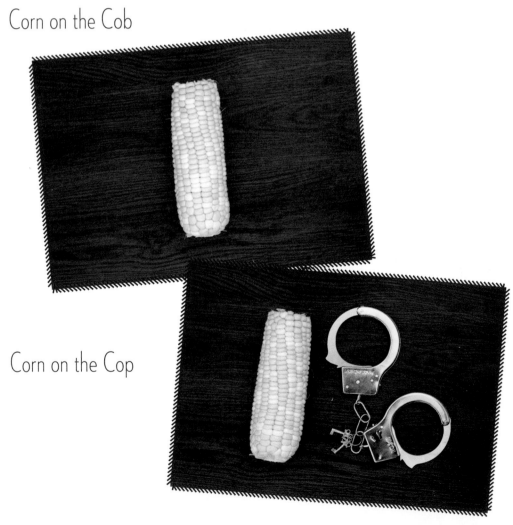

Corn on the Cop

Corn-on-Corn Action

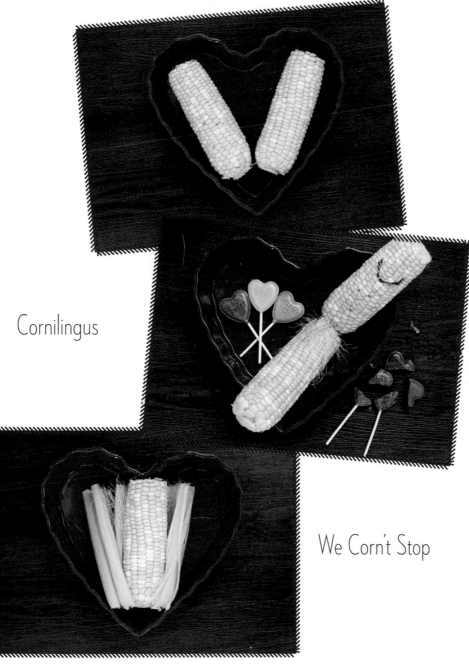

Cornilingus

We Corn't Stop

You liked that, didn't you? Filthy mothershucker.

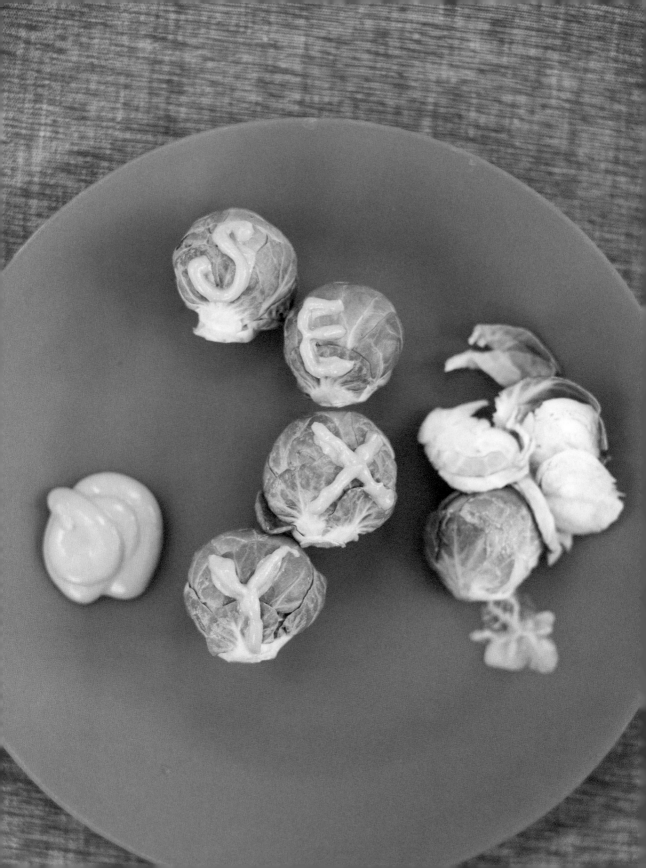

{ BROTHEL SPROUTS }

Endurance is the crowning quality,
and patience all the passion of great
hearts.

—JAMES RUSSELL LOWELL

(Based on a true story.)

Grrrl, it smells great in here . . . well, actually it smells kind of stinky but whatevs.

Whatchu makin'? Ooh, yeah, brussels sprouts? I dig that.

Oh shit, you bought those at the farmers' market, didn't you? Yeah, you dirty like that. Organic and shit.

They were still on the stalk? That's freaky naughty, grrrl, yeah.

Just boiling them, huh? That's cool . . .

You know . . . that looks great, but . . . boiling them?

I mean, you could roast them with onions and potatoes.

Maybe some balsamic . . . just need a little oil and salt and pepper.

And if you cut them in half they cook pretty fast.

And if you switch to the broiler for the last ten minutes or so the leafy parts will get all crispy and taste delicious. In fact, I can show you if you like. We just gotta stop boiling those ones right now because it smells really bad and also ends up totally bland . . .

Whoa! Baby, where you goin'? No reason to get so mad! Yeah, I know you've been cooking, but I mean . . . I'm just being helpful. Do you want a tasty dinner or what?

Hey! Those are my keys!

. . .

. . . Shit.

Life Lesson

If someone is trying to do something nice for you, it's best to just let them finish.

Even if you know a better way to do it, they might just want to make it their way so they can share part of themselves with you. Sometimes it's best to sit back, relax . . . and compliment profusely.

Dating Your Age: Choosing a Wine by Year

I've exclusively dated people who are younger than me. I don't know why. I don't have a good reason for it, and I've been told that I should really think about dating older women who are more in line with my maturity and where my life is heading. But then my counterargument has always been: if someone older than me is dating me . . . does that mean that they are emotionally stunted? Why can't they find someone their own age, or even better . . . older?

This is related to the aging of wines. You can buy a young wine, but that doesn't mean it's going to age well. Or you can buy an old wine, but sometimes it just tastes like vinegar.

In the end, just don't judge a love by its label.

{ ROLLPLAY }

> Good sex is like good bridge. If you don't have a good partner, you'd better have a good hand.
>
> —MAE WEST

Let's be real. After you've been with the same person for a long while, and you're pretty sure that this is the person you are gonna be with for THE long while, you might want to try something a little adventurous in the bedroom.

Here's a fun (and effective) way to bring up the conversation.

Cocktail

Something surprising but seems like a thing they would like. The point is to get them to say, "Oh my, this is good. Have we had this before?" and then you can reply, "No, but I thought it might be nice to try something new . . . ," and then hold eye contact for a *really* long time.

Ingredients

* dinner rolls * the right timing

Instructions

Serve dinner, and then just as you're about to eat, jump up like you've forgotten something . . .

Grab the rolls from the oven and while they are still warm put them on the table.

Pretend that you burn your finger and be like, "Oh no! My finger! Good thing you're . . . a . . . doctor?"

Then wait to see if they go with it.

Life Lesson

Here's the thing: So maybe you've never done something like that before and maybe it will be awesome or maybe it will just be hilarious. The point is that it should never be embarrassing or humiliating (unless you like that) because this is your partner and they love you. Conversations about bedroom antics should be a form of communication like any other. Open, honest, patient, and understanding.

If you are in it to win it with somebody, you've got to trust them enough to be vulnerable.

And depending on the shit you're gonna try out . . . maybe you're gonna end up being *really* vulnerable (see Hot-Crossed Bunz, page 158).

WHAT YOUR FAVORITE BREAD SAYS ABOUT YOU ROMANTICALLY

Country Potato: You're ready to settle down and make some spuds.

Sourdough: You've seen it all and are also the sexiest of the breads. So sexy nobody cares if you smell.

Marble Rye: Your parents are mixed race and that has made you very multicultural. Congrats! You're the next step in evolution.

Pretzel Bun: You may have a hard, salty exterior, but inside you're as soft as they come.

Whole Wheat/Multigrain: You're a health nut, but don't judge others for the terrible choices they are making regarding their bodies. You just want them to see that you care about yours.

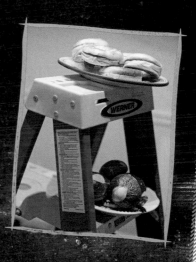

{ HOT-CROSSED BUNZ }

Everything in the world is about sex except sex. Sex is about power.
—OSCAR WILDE

You've been real . . . um . . . naughty . . . so . . . now . . . um . . .

Cocktail

ANYTHING BECAUSE A DRINK RIGHT NOW WOULD BE GREAT. PLSKTHX.

Ingredients

* Consent!
* Also a safe word! Could be anything! Maybe an exotic fruit?
* Also some freshly baked hot-crossed buns to eat after. (Or during? I don't know, I don't like to mix food and sex because I don't like being forced to choose.)

Instructions

Well, the first thing I would do would be to log on to YouTube and look up instructional videos, but that search might descend quickly into porn. So, there's that.

However, there *should* be a video or two that will actually prove to be a bit helpful when it comes to not damaging any nerves or wrists or bones . . . not that I had to watch one or anything . . . I mean it was just to figure out how to do it for the picture!!

After that I think that you then . . . do things . . . I don't know! I am uncomfortable! I'd like to skip straight to dessert, please! Also, where is the alcohol??

Life Lesson

As I've mentioned before, I personally believe that all good sex stems from healthy trust.

If you trust the person you are with, then I'm pretty sure you can engage in some freaky nasty goodness to keep yourselves interested.

And who knows! You might like it! No judging! I don't know!

Point is, be sure to try new things.

But in a safe way.

"Pomegranate."

{ TEAR . . . AH MISS YOU }

Morning without you is a dwindled dawn.

—EMILY DICKINSON

However, there comes a time when relationships end. And sometimes that happens before you wanted it to. And you get dumped. And getting dumped is hard. Like really hard. It's entering a process of mourning for a time in your life that is over.

Or is it?

See, here's the thing. I'm like *super* determined when it comes to relationships. When my first girlfriend broke up with me I was devastated. And also completely obsessed with her. I think I should be a private eye for the amount of stalking I did of her Facebook page after she left me. But then again, I was nineteen and in the closet and totally desperate to not actually be gay.

Point is that instead of stalking someone's Facebook, maybe just pour all your salty feelings into a cake. An Italian cake.

Cocktail

Rum from da islands.

Ingredients

* rum
* ladyfingers (hey girl)
* white cake mix
* instant coffee powder
* cream

* coffee liqueur (not from da islands)
* sugar
* cocoa powder
* mascarpone cheese

Instructions

Take the rum that you would have baked with and then just drink it mournfully while dipping ladyfingers into your glass. Try not to think about how great your sex was . . . despite the recurring ladyfinger-based jokes you're making in your head. Get a spoon and start eating mascarpone cheese. Try not to think about spooning. Find an Italian place that delivers tiramisu. Send it to her house. Drunk-text passive-aggressive jokes: *"You really take the cake! And by 'cake' I mean 'beating heart from my body.'"*

Life Lesson

Breakups bring out the worst in me.

Abandonment issues prevail and suddenly someone who really isn't right for me or doesn't treat me well seems like the only thing I need/will need/have ever needed. But once I learned this about myself it was a lot easier to take/give breakups accordingly. So now, every time a romantic relationship ends I just bust out my journal and write: *"Thanks a lot, Mom and Dad."*

BREAKUPS AND BREAKDOWNS: WHAT TO COOK AFTER THE LAST DATE

When I get dumped, I can't eat for months. Well, that's an exaggeration, but it is certainly much harder for me to eat. I just affiliate food with happy times, and, clearly, being dumped is not a happy time. Even a little bit. So, I don't eat a thing, but I know I need to eat because being too skinny seems gross to me. Also, I like to give good hugs and if I'm bony that means my hugs will make people slightly uncomfortable. Here are some things I find easy to eat despite the lead in my stomach.

- Pastafarian, page 90
- Naan of Your Business, page 105
- Sad Thai, page 165
- Latke Shotkas, page 17

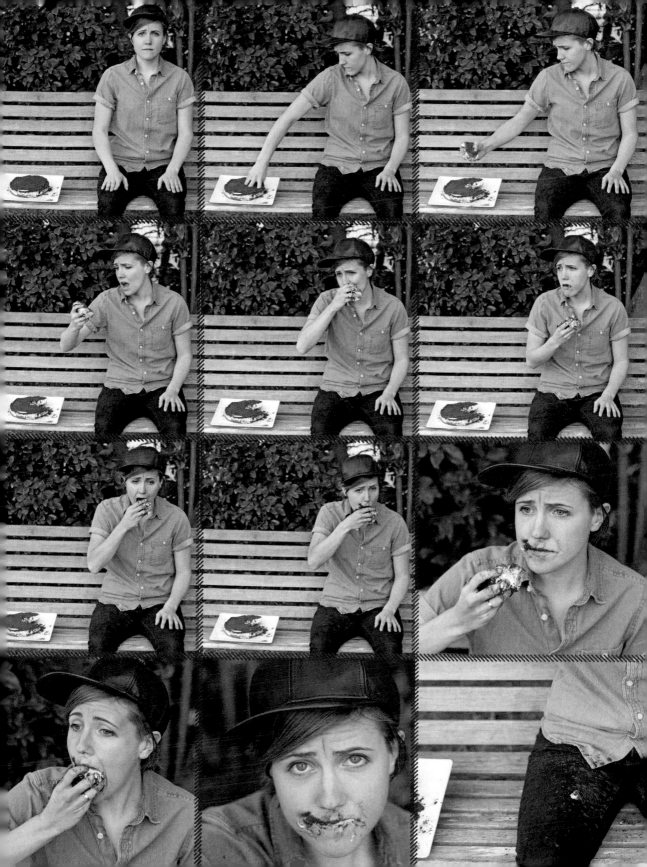

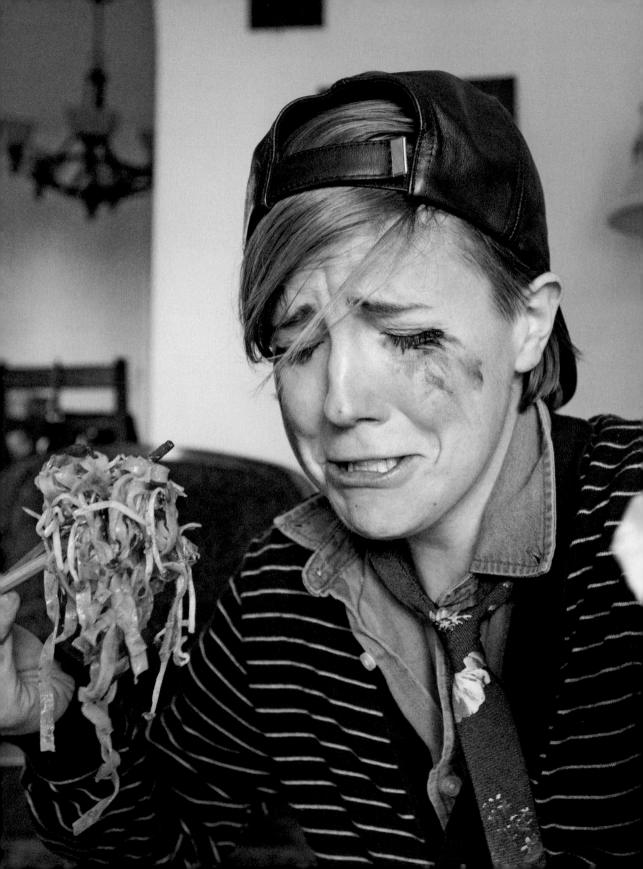

{ SAD THAI }

If I had a flower for every time I thought of you . . . I could walk through my garden forever.
— ALFRED TENNYSON

But let's keep talking about the end of a relationship, because this happens to people more times in their life than does finding and meeting the perfect person. (Which makes sense when you think about it because after you get dumped you're going to keep looking.)

The end of any relationship will take you through the five stages of grief: denial, anger, bargaining, depression, and acceptance. As you've just read, Tear . . . Ah Miss You conveys the first, second, and third states.

This recipe will explore the fourth and fifth states—depression to acceptance.

Cocktail

Thai Beer. Singha . . . to SINGyourHArt . . . out . . . at karaoke later.

Ingredients

* your empty den of sadness
* access to a phone book or the Internet
* credit card or cash

Instructions

Step 1: Lift your head from your pillow. Don't worry if the sodden fabric is sticking to your face due to the amount of tears you've shed since that bitch broke your heart. Well, I guess she's not really a bitch,

just another human, flawed and fragile, in fact maybe she's really wonderful and that's why she's not with you anymore. Same as always. Now cry and go back to sleep.

Step 2: Repeat Step 1.

Step 3: Repeat Step 2.

Step 4: Order Thai food from that place down the street. She always hated that place. Said it was too greasy. Well, now you can have Pad Thai for the first time in seven months, so maybe things are looking up.

Step 5: Wash your face before the delivery arrives. If you're feeling adventurous, maybe even take a shower and put on clean clothes.

Step 6: Receive Thai food. Maybe even try to hug the delivery guy because he's really nice for coming so early in the morning. Most places don't start delivering until after 11 a.m.

Step 7: Okay, he's not into the hugging so just tip big and back away.

Step 8: Eat noodles. Watch TV. Call a friend.

Life Lesson

Some people find that at the end of a relationship they like to get a haircut or start working out. New Year's for the soul or something.

For me, I like to have one solid day of wallowing in abject misery. My Irish wake for the loss of that love.

Except I replace the whiskey with carbs. Not to say that I don't love drinking! But now is probably not the best time for it.

> **PRO TIP:** While in mourning, it's best to avoid watching TLC, because there is pretty much always a *Say Yes to the Dress* marathon on and you're just not ready for that yet.

{ COLLARD BACK NOW }

The truth is, everyone is going to hurt you. You just got to find the ones worth suffering for.

—BOB MARLEY

I've talked a lot about how to cope with being dumped. But what if maybe you're the asshole who broke up with them for the wrong reasons?

Follow these simple instructions and find a way to change. Because this time around life didn't hand you lemons, you brought your own.

Cocktail

Green juice is good for you! Now just spike it with Midori Sour and they shall be none the wiser.

Ingredients

* collard greens
* reflections
* time spent apart
* maybe some talk therapy and soul-searching

Instructions

First, go to your local grocer and ask them what collard greens are. Great. Now buy some.

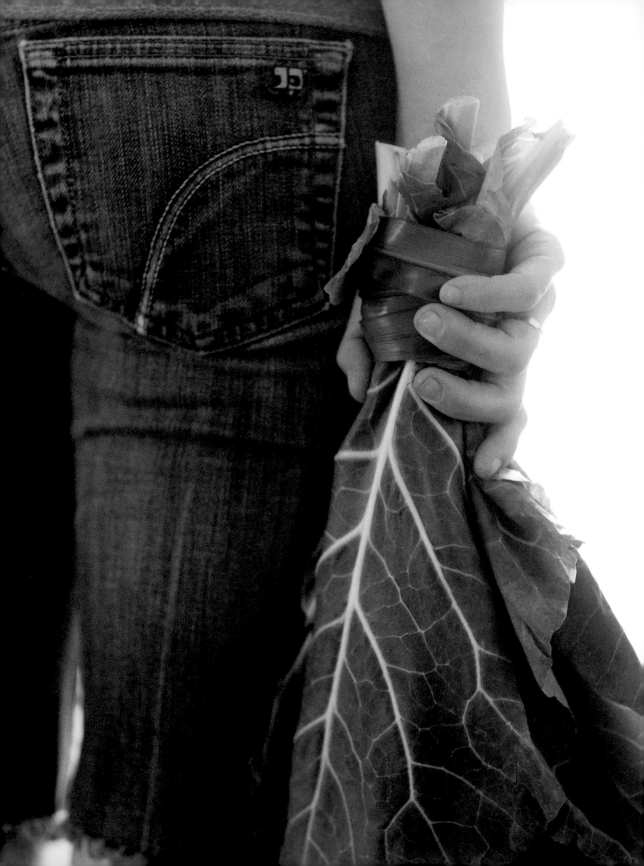

Find a piece of twine and tie the greens together like an adorable bouquet of apology.

Show up at your dumpee's house unannounced and tell them that you're sorry and that you've changed your ways. Maybe hand them a letter you've written that explains who you were at the time and how it really wasn't anything that they did or said. But you're working on your stuff and you want to give it another go.

Oh, ouch. They have moved on?

Oh, snap. That new person is here right now too?

Slowly back away and pretend like all of this was a dream. It will help if you wiggle your arms and make whooshing noises.

Life Lesson

 We all have regrets, but it's important to learn from them and not dwell on the things you cannot change.

If you marinate in negative thought, you may just become a bitter regret stew that nobody will ever want to eat again!

So, do yourself a favor and cook those veggies of self-improvement! That should clear away any built-up emotional baggage that you may be carrying in your lower intestine.

You are now an expert on the art of living *and* loving. Aren't you just such a beast of knowledge? Ooh la la, I think I may be swooning! No, wait. That's just low blood sugar. Here, you review a bit while I go and have some slices of provolone:

- **Crude-ités**
 (How to seduce through ART.)
- **String (Cheese) Theory**
 (Because your friends date people too.)
- **Breakfast Pizza**
 (Nothing says love like breakfast.)
- **Quiches in Scoops**
 (Please don't date people you hate.)
- **Chocolate Chipz**
 (Compatibility is based on more than just common interests.)
- **Heart-Beet Salad**
 (Compatibility is based on just one common interest . . . puns.)

- **Ca-Pray-Zay**
 (Nothing says seduction like a classy cheese salad.)
- **Brothel Sprouts**
 (It really is the thought that counts.)
- **Rollplay**
 (Suggest new things! For sex! Sometimes! Just kidding!)
- **Hot-Crossed Bunz**
 (Communication is the key to the kingdom.)
- **Tear . . . Ah Miss You**
 (Getting dumped is the worst . . .)
- **Sad Thai**
 (. . . but it does get better . . .)
- **Collard Back Now**
 (. . . even if it was all your fault.)

Now that we've talked about meeting/dating/seducing/loving/leaving, let's dive a little deeper into the realm of romance known as "being a big sweetie." It turns out that there is a way to actually determine how to best give and receive love. Interested? Well, read on, my wayward son! Become a master of the heart!

CALL-HER-FLOWER
(HOW TO BE CONSIDERATE IN A WAY THAT IS GOOD FOR YOU TOO.)

✳

We all like to be shown demonstrations of love in different ways, no? For instance, maybe you like to be surprised at work and taken out to a romantic lunch. On the other hand, maybe that's the exact sort of action that makes you annoyed because they should know how busy you are and it was bad enough that they sent an ornate bouquet of pink peonies right before you had to go into a client meeting.

Anyway! There's actually a really great test to figure out what sort of "demonstration of love" you appreciate. Apparently, there are five languages of love that people have in their hearts:

> **Words of Affirmation:** Being told that you're great and attractive and appreciated.
>
> **Acts of Service:** Having someone help you accomplish your tasks/projects.
>
> **Gifts:** Presents!!!
>
> **Quality Time:** One-on-one time with full attention.
>
> **Touch:** Hugs. Kisses. Snuggles. Cuddles. Spooning. Forking. Etc.

I think the idea behind the love languages started in the seventies or something, but I took the test recently and it really makes a lot of sense! I found out that I am the type of person who responds to acts of service (because let's get real, drunk kitchens don't clean themselves) and . . . receiving gifts?

I was really surprised by this because I've never considered myself to be particularly materialistic. But then it occurred to me that a "gift" to me could be something as simple as a new set of pens, and that feels very

loving because (A) the person knows me and (B) it's also just so useful!

So here's a word of honest advice: take the test and see if it makes sense to you. Sure, it's kind of ridiculous and sappy and whatnot, but it's something to know about yourself that will prove to be useful in future (or current?) relationships. And not just romantic ones. Friendships too!

Also, how cute is this image? Twenty bucks says there's already a store that specializes in bouquets made from vegetables. If not, there is a real market for it.

At this point, we've covered the basics of being in the kitchen, the adult you are today, and the love you create in your life. These three sections are the ingredients of your life as it stands today.

So now, let's move on to the ingredients that made you to begin with.

FAMILY AND THE HOLIDAYS

You Are Your Own Tradition

One time my sister and I washed a turkey in a bathtub.

Well, we didn't "wash" the turkey so much as rinse it. I mean, you're supposed to rinse poultry and meats in cold water before cooking them, right? Not that I really understand why. It seems to me that if you're going to heat something to such a temperature that the raw meat itself would cook, then how could germs survive, rinse or no rinse?

Either way, we washed a turkey in a bathtub.

And it wasn't really "a" bathtub. It was "the" bathtub in our house. We had about six people living with us (or at least in and out of the house) at the time and my older sister and I decided to have a Thanksgiving. I honestly don't remember where the turkey came from, or even whether

or not it was cooked at any point, yet I very distinctly remember washing the turkey in the tub and feeling like we were really getting something done. And that we were getting it done right.

I remember making mashed potatoes. And that they had garlic and salt and pepper and butter and milk and that everyone seemed to like them. But I don't really know if that was the same year. I don't think it was?

I remember getting one present a year for Christmas, and one year I got a stuffed tiger that growled when you squeezed it. And I remember being so desperately happy.

I remember that it was tradition to spend all the money on having a real tree because it would still be beautiful with paper ornaments. But a plastic tree with real ornaments? No way. Get real. What are we, Catholic?

And we always would buy our trees in the rain because that's when they smelled their best.

And I also remember being very small and having dinner at a soup kitchen. But I don't know if it was Christmas or Thanksgiving. I just remember feeling very full and sleepy. And then being interviewed by the local news about the holidays.

Thanksgiving was my favorite. In fact, it still is.

See, a lot of people complain about the holidays because they are the time of year when you are asked to leave the comfort of your self-constructed adult life and revisit the emotional baggage of your childhood (see Trifle Troubles, page 189).

But I wonder if part of this tension stems from the idea that there is some traditional or conventional way you are supposed to celebrate the holidays with your family. I just don't believe that there is. I think that everyone has memories that they treasure and hold sacred around traditions, or moments of happiness shared during holidays, no matter how difficult the circumstances may have been.

Frankly, I didn't write this chapter for a long time because it's hard to write about family. Not just my family, but all concepts of family. The thing is . . . it's kind of very difficult to talk to people about how families are because every family is different. Every single family is different. Because every person is different. But that being said, there are certain elements of dealing with family that remain the same:

- **Hope:** That someday this person who means so much to you will wake up and be the person you've needed them to be.
- **Disappointment:** The fear that keeps you from acting out of hope and giving them the chance to be that person.

- **Hope:** That maybe this will be the year that you've grown enough to accept them for who they are, not who you want them to be.
- **Disappointment:** That despite all you have, who you have, and what you've become, there are certain people in your life who find a way through the breaks in your armor and make you question everything by hitting the soft spots you protect year-round.

Despite this cycle and the hesitation it inspires, I for one fully endorse going home for the holidays. Mainly because you can see who never left. Or who has kids now. Or who really peaked during their popularity spike of senior year. Isn't it great that you hit puberty in your mid-twenties? Otherwise you might have a personality defect that I like to call "Asshole." Those people sometimes become cops.[*]

I also fully endorse going home for the holidays (or making a holiday of your home) because it's important to celebrate the lives we have. Or be grateful for what's been given to us. Or just sit through the painful phone call you don't want to make because it's Christmas and you can continue to ignore them for the next 364 days after this.

So what is the best solution for dealing with this cycle that binds/blinds us? Probably talk therapy.

But if that's too expensive, there's always . . .

Drinking.

Anyway, the recipes ahead are meant to help you cope. They are not designed to help you ignore, repress, or disregard the natural difficulties of interacting with family. They are simply meant to put a little courage in your pocket. Like the gentle squeeze that comes from the hand of a partner under the dinner table because maybe their family doesn't know that you're madly in love with each other and their grandma keeps trying to set you up with their eldest male cousin who is also clearly gay and dating his roommate.

Just have another glass of wine and think of your favorite carol to sing.

Also, there's pie.

[*] I love cops. But the ones who do it to protect people, not because they want to carry a big stick.

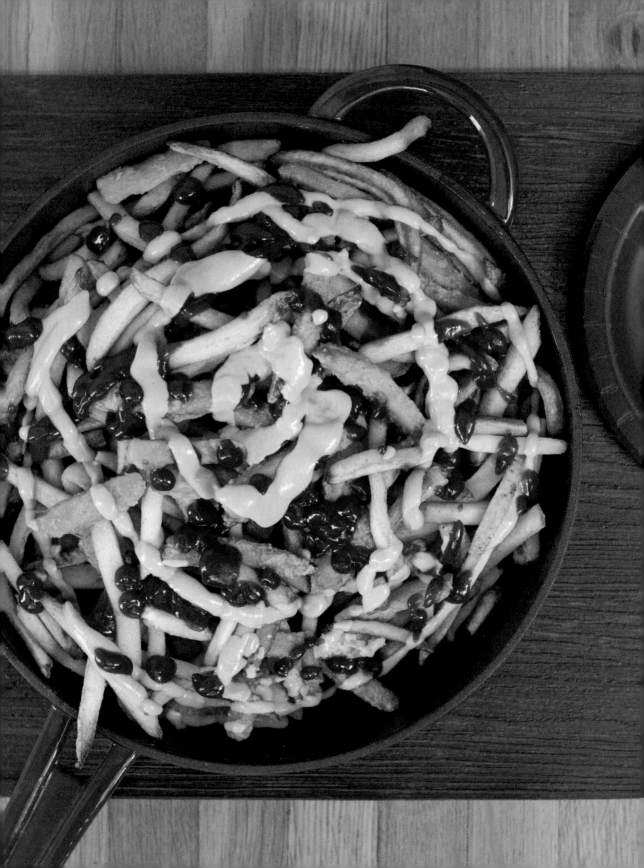

{ STIR FRIES }

Siblings that say they never
fight are most definitely hiding
something.

—LEMONY SNICKET

Similar to siblings, French fries all stem from the same family, the potato family. Yet each
and every one is different. A different shape, a different flavor, a different purpose, etc.
Now, despite these differences, each French fry in the batch will share a similar origin
story. However, the outcome will be unique. The point is to have patience with your
sibling French fry and realize that life imprints differently on each and every one of us.
Some of us will be salty, some of us will be peppered, but in the end we are all just trying
to catch up.

French fries are irrefutably one of the most important drunk foods. A French fry is a
perfect starchy slice of love and joy, dancing delicately from the plate before you to its
permanent home in your mouth cave and then finally to the resting place of your tum-tum.

Commonly, people in Western civilizations like to consume French fries prior to a night
of exploits and debauchery. "A good lining for the stomach!" some might say. "Yum!
French fries!" others might say. However, I might say: "But what if we mixed a bunch to-
gether and refried them on a skillet?"

Cocktail

Vodka and soda. Simple and clean, nice and lean, ready to clean . . .
up your spleen.

WHAT DID THE SAUTÉED VEGGIES
SAY TO THE FRYING PAN?

YOU'VE GOT SKILL-ETS.

Ingredients

* French fries
* waffle fries
* sweet potato fries
* garlic fries
* curly fries

Instructions

Oh, I think the instructions are pretty clear. Put these motherfuckers on a frying pan and let them duke it out with each other for the undivided attention of your taste buds.

Life Lesson

(GET IT—KETCHUP???)

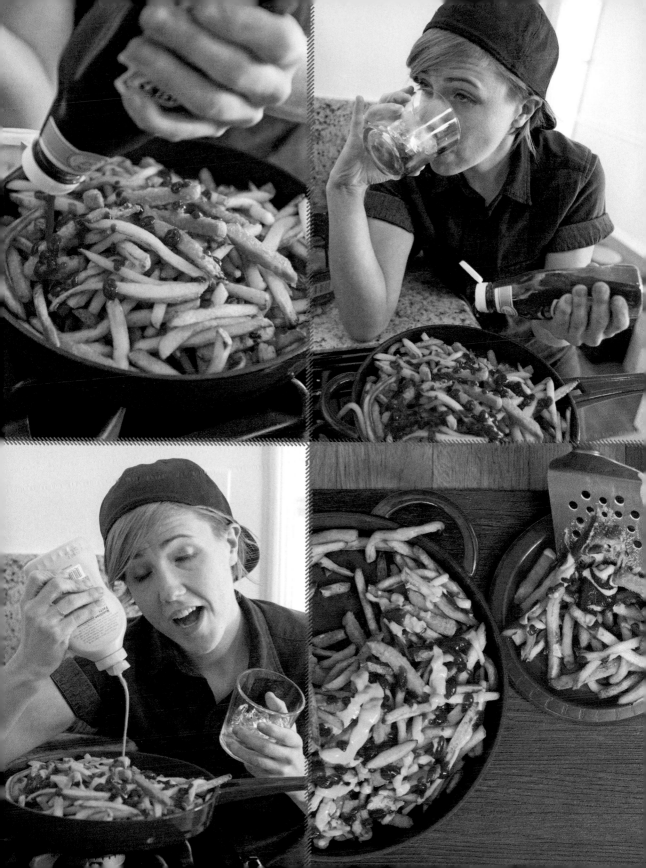

{ PATTYCAKE }

The Greek word for "return" is *nostos. Algos* means "suffering." So nostalgia is the suffering caused by an unappeased yearning to return.

—MILAN KUNDERA

Don't dwell on a past you can't change. And ultimately, I feel like even nostalgia is a little bit pointless. There's no real reason to obsess over it, is there? I mean sure you can "learn" from it . . . but I'm more concerned with understanding *how* to be with the way that I am, not so much *why* I am the way that I am.

This is very similar to the way I feel about the game Pattycake, because it didn't really seem to serve a purpose in my mind. Not like Quack Diddily Oso, the game that involved routine elimination based on a mixture of luck and skill. Rumor has it that's where the idea for the show *Survivor* came from. That's a really true fact.

Cocktail

What's in the cup on the table? Grab that. But check for drugs. Has anyone invented a Pocket Party Kit so people can test for drugs at parties? Like with litmus paper and acids?

Ingredients

- ∗ frozen patties
- ∗ of meat

- ∗ or veggie
- ∗ or salmon! Yum.

Instructions

Strap two frozen patties to your hands and clap them together hoping for enough friction/heat that they will start to defrost and cook. Isn't it fun to think about childhood?

Play with a cousin . . . that you hate.

Life Lesson

Sometimes you just need to let it go.

Especially if "it" is a rapidly defrosting beef patty.

SUGGESTIPE

What's a suggestipe, you may ask? A suggestipe (*SUG-jest-ih-pee*) is the combination of a suggestion and a recipe. It contains the considerate input of a suggestion but includes the added benefit of structure that comes with a recipe.

See, I think that it would be really helpful if we could talk to our friends and ourselves this way. Instead of just saying "look on the bright side" and waiting for the change to happen, wouldn't it be great to include some steps toward that bright side? It would alleviate the frustration that you feel toward a friend you've told your complaint to who has offered feedback and is "just trying to help." And it sucks to feel such annoyance at someone who is "just trying to help." And it usually leaves the complaining party feeling guilty and bad on top of the issue they were already dealing with.

For me, I am often scolded for being a bit preachy (can ya believe it?), or a nag, or overly concerned with other people's happiness. Or even overly critical of myself or others. It's my worst quality, I think. Focusing on nothing but the flaws and tuning out the triumphs. And sometimes when I talk about this with my friends, they suggest that I "chill out" or "let it go." And though they are correct in their intention, "letting it go" is really hard for me to do. Thus that suggestion alone isn't helpful to me because I can see no path for transitioning my thought train.

But if there was an order of execution included? Wouldn't that be so grand?

Now, suggestipes would need all the same elements of a traditional recipe: a designated end result (with description), the allotted time it takes, the list of ingredients, the order of the process, etc. Here are some suggestipes I designed for myself.

{ LET IT GO }

Free up space in your head to think about other things and not harp on that one thing that is seriously pissing you off right now.

Prep time: 1 minute
Cook time: 5–60 minutes (varies on skill)
Total time: 6–61 minutes

INGREDIENTS

* momentary solitude
* fresh air
* paper and pen

INSTRUCTIONS

Step 1: Physically remove yourself from the situation that's causing you aggravation. (Note: If you're at a meeting, then you may just have to momentarily remove yourself mentally.)

Step 2: Look into the distance and take a deep breath.

Step 3: Using paper and pen, write out the reasons you are frustrated.

Step 4: Next, write out what is and is not in your control.

Step 5: Now write out one (or more!) positive element of this situation, despite it being frustrating. (Note: If you can't think of anything positive related to the situation, expand to include anything about anything, just as long as it's a good thing. Example: "My hands work well enough to write this sentence.")

Step 6: Once you feel calm, return to the task at hand and resume.

Now, trust me, I know this seems really cheesy! But it actually works. Or at least it does for me. And it doesn't have to be about letting things go! It can be about anything (or any goal) that you have trouble accomplishing. Sometimes writing it out in an unorthodox format like this will give you fresh incentive. Let's try it again with something lofty, like cleaning out the garage! (Get it . . . *loft*y? . . . Like a loft? . . . I'll show myself out.)

{ CLEANING OUT THE GARAGE }

Create a tidy and organized space free of junk and also maybe convert it into a cool indie-bar space for you and your friends.

Prep time: 1-3 hours
Cook time: 4-5 hours
Total time: 5-8 hours (an afternoon, or maybe a weekend)

INGREDIENTS

* cleaning supplies
* storage containers
* trash bags
* the neighbor's kid who will help you lift heavy objects for $50/day
* beer

INSTRUCTIONS

Step 1: Commit.

Step 2: Assess the task at hand, and prepare supplies necessary for execution.

Step 3: Clear out schedule.

Step 4: Get supplies on a different day. Then do cleaning day.

Step 5: Clean dat shit.

See? That works really well, doesn't it!

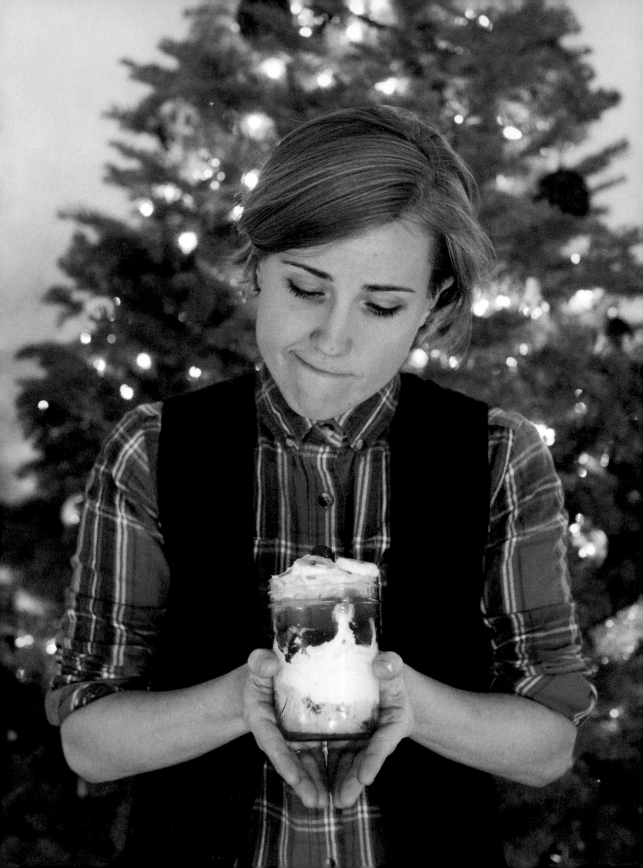

{ TRIFLE TROUBLES }

It is not a lack of love, but a lack of friendship that makes unhappy marriages.

—FRIEDRICH NIETZSCHE

Now, let's talk about the holidays and holiday desserts. A trifle, for instance!

Like the holidays themselves, this can be as simple or as difficult as you'd like to make it. For instance, if you decide, "Hey, I've got a million hours of free time today! Maybe I'll make every ingredient from scratch," then that's cool! But you're not gonna find that here. Much better to go and buy a book that's gonna instruct you how to bake a cake, or make custard, whipped cream, and your own homemade jellies. The only thing you'll find here is an appreciation of mason jars.

(A trifle is a British dessert that is basically just spirit-soaked sponge cake layered with custard and fruit. Doesn't that sound absolutely delicious? I would eat some right now if I could. But instead I'm writing a book. #firstworldproblems)

Cocktail

Sherry, baby!

Ingredients

* more sherry!
* sponge (or pound) cake
* custard (vanilla pudding cup?)
* jelly/berries/fruit-type things
* whipped cream (if you have)

Instructions

Pour sherry into a mason jar. Then take a sip. Then be like, "EW THIS IS SO DAMN SWEET." Then soak up some of the sweetness by putting sponge cake into your jar. Then take a vanilla pudding cup from the fridge (because maybe you just had a craving for pudding cups?) and also dump that in your mason jar. Then be like, "What's the difference between pudding and custard? Nobody knows." Then put some jelly on the top and add whipped cream.

Then drink from the sherry bottle from now on because somebody put a trifle in your cup. The nerve.

Life Lesson

Be patient with your spouse during the holidays.

You guys are both stressed out and it's a tough time of year. There's a lot of expectation going around, and when that happens you just can't sweat the small stuff. After all, you're on the same team.

Team Trifle.

CHRISMUKKAH!

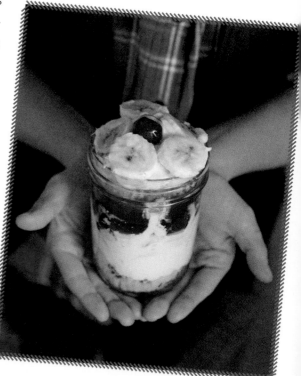

{ PANSTEAK }

If winter comes, can spring be far behind?

—PERCY BYSSHE SHELLEY

So you're cooking for the family, but you don't really have the time to invent a seasonally appropriate recipe to honor the winter months. Well, try this one for size! A new spin on the pancake! In that it's not at all like a pancake even remotely. It just involves a pan. So this is basically like calling anything you cook on a pan a pancake. Stir-fry? Pancake! Omelet? Pancake! Salmon fillet? Pancake!!!!

The point of this recipe is just to add maple syrup to something and call it "winter." You've only got a couple more months to get through.

(Ew. Hold up. I just noticed how dirty my laptop keyboard is. Hold on while I wipe it off real quick. It's like mega gross and distracting. It looks like someone eats at their computer a lot. Or cooks with it open next to them in a kitchen while getting drunk.

azxso90=[]lpsw2\0-q1\

=lp0-azÐÐÐÐÐÐÐÐAÐÐPÐÐ

^^^Apparently that's what it looks like when you wipe off your keyboard. I'm gonna leave it. Maybe it's a code.)

Cocktail

Shiraz! Because you're Shiraz shit gonna need to be drunk to eat this.

Ingredients

* thinly sliced steak meat
* maple syrup

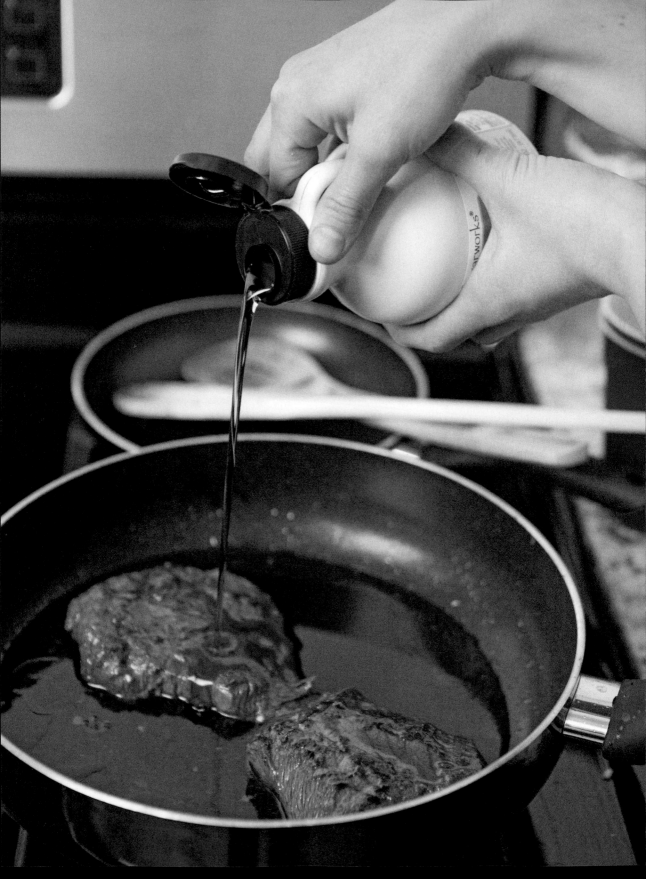

Instructions

Go to your local Mexican grocer and tell them you are making carne asada (WHICH IS DELICIOUS BY THE WAY). Then go home and pan-fry your thinly sliced steaks and create a maple syrup glaze. Don't know how to make a glaze? No problem. Just pour maple syrup on that thing. Then walk away, because you don't have time to worry about making seasonally appropriate meals when you're just trying to get food on the table.

Life Lesson

Your aunt is a vegetarian now, so use tempeh and call it a Panfake.

LET'S TACO 'BOUT IT: COMMUNICATION TIPS AND TRICKS

Never hold back from expressing your thoughts and feelings. It's really not okay to just assume that nobody is going to understand you. At least give them the chance to understand you. It's hard to make yourself vulnerable, but when you constantly set yourself up for disappointment, there is no room for them to prove you wrong. However, it's true that people will not suddenly, magically become the people you want them to be. If someone has given you ample reason to doubt them—reason stemming from prior actions and results despite multiple attempts at change—then you can go ahead and cut that one loose, I'd say.

But check yourself. If you're going to assume constantly that people are going to let you down, then that might be a good sign that you're the one who is doing the down-letting.

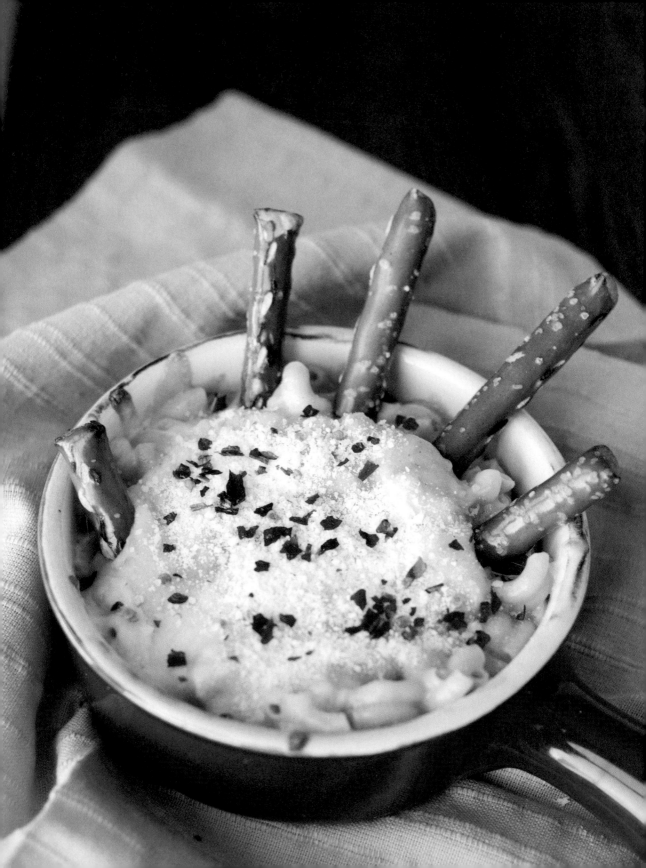

{ MACARONI . . . PRETZEL . . . HAND? }

Times are bad. Children no longer
obey their parents, and everyone is
writing a book.

—CICERO

At this point, you may be not only dealing with your own childhood triggers, but also bearing witness to the formative years of the children around you that will later require years of therapy for them to deal with. *(Hi, nieces and nephews! Sorry your mom is cuckoo-pants!)* A great way to interact with kids is to cook with them. You are at once playing, teaching, and feeding them.

Now, baked macaroni is one of the most delicious forms of macaroni. It gives the noodle dish the one thing it was lacking: a deliciously bronzed bordering-on-crustlike top. But in this recipe we also include pretzel rods for texture.

Also, it's just funny to take pretzel rods and stick them out of things like a hand in quicksand.

Cocktail

Pinot Grieve-io. Because you are still mourning the loss of that one
onion you loved.

Ingredients

- * macaroni noodles
- * Gruyère
- * Swiss
- * smoked Gouda

- * Parmesan
- * pretzel rods
- * red pepper flakes

Instructions

Make macaroni and cheese but this time add all the cheese in your fridge. I've suggested my personal favorites above. Smoked Gouda is especially good, I think. An aged smoked Gouda is so good-a it's great-a.

Once you've made your mac, put it in a bowl and make another layer of cheese on top. Then put it in the broiler. Then sit on the floor because, as you know, we don't leave the room when things are in the oven. For this reason, I also advise you to keep a stack of books or magazines in a kitchen drawer. If a guest stumbles upon it, just be like, "Quit creepin' on my drawers, yo," and they will be like, "Don't speak to your grandmother like that."

After you remove the mac from the oven, wait for it to cool. Become instantly bored and stick pretzel rods of differing lengths in it to create the illusion of a hand. Sprinkle with red pepper flakes. Presto!

Life Lesson

This dish is a lot like French onion soup,

but instead of the French-onion part you've got baked macaroni and pretzel rods, which are clearly light-years ahead of French onion. What makes an onion French, or not, anyway? That's the real question. Like, at this point, I know that there are red onions and yellow onions. But what makes one French? Like a little swirly mustache? That would just make it cute. And then you could never eat it. And you'd have to keep it in your fridge until it rotted. And then when it went bad you'd return it to the earth from which it came. And then maybe while you watched the sun dip below the horizon you'd pause and think, "Man, I should make mac for dinner."

{ LET'S GET GRILLED }

(ABOUT YOUR LIFE CHOICES)

> Accept the children the way we
> accept trees—with gratitude,
> because they are a blessing—but do
> not have expectations or desires.
> You don't expect trees to change,
> you love them as they are.
>
> —ISABEL ALLENDE

You know, you're really trying to have a relationship with your dad. But man. He is just such a prick.

Cocktail

Bud Light. Because that's all he wants to drink so that's all anybody gets to drink.

Ingredients

* one disgruntled father figure who never achieved his goals
* one crazy notion that maybe things would be easier if you hosted the family reunion at your place this summer
* BBQ supplies
* foodstuffs

Instructions

Take deep breaths and remain calm.

Don't bother reminding him that you don't eat red meat.

He's already grilling.

Move on and try to talk about a neutral subject like the weather. Oh no, now he's talking about climate change. Now he's bringing up the "liberal scientists getting paid by the welfare committee" argument, which makes absolutely no sense, but now the conversation is leaving your control completely and oh no . . . he's bringing up politics. Quick! Point out that a bun is burning!

Okay . . . steel yourself for round two. Bring out the hamburger patties. And cue discussion of how you're applying yourself. Lord knows he did a better job when he was your age. Ignore the fact that this is a total lie. Poke meat with skewer. Get scolded. Walk away.

Food is done! On to the final round! Set the table and stuff your face. If you keep your mouth full there's no way he can ask you questions about . . . oh good, he likes the grill you bought . . . no, your boyfriend didn't pick it out . . . you don't have a boyfriend . . . why? Because you're still gay?

Annnd silence. Great. We can work with that.

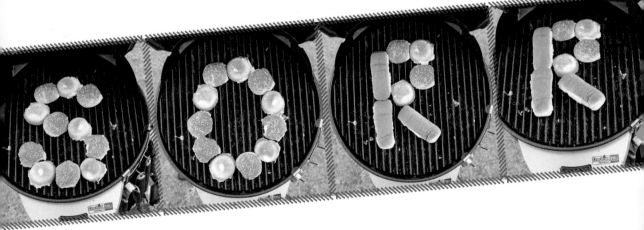

Life Lesson

There are certain people who will always seek to criticize.

This has nothing to do with you. It must be hard to be inside their head, you know? I mean if they find so much fault in everyone around them . . . then one can only imagine the faults they must see in themselves.

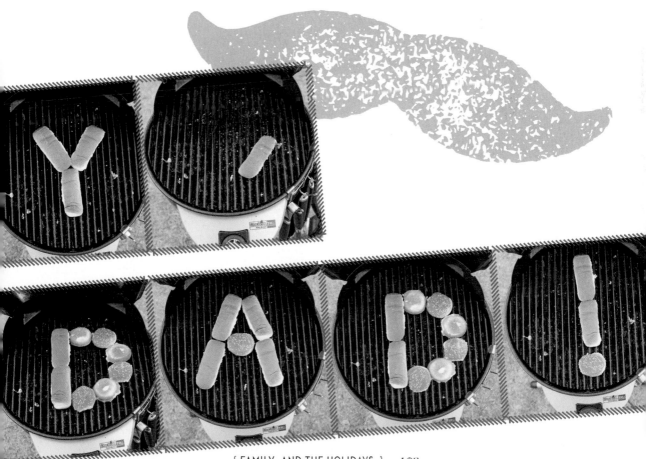

{ ENMESHED POTATOES }

ENMESHMENT: generally applied to an engulfing codependent relationship with an unhealthy symbiosis

Dealing with family can make us feel angry. But we don't want to take that anger out on anybody, do we? Especially not ourselves!

So! If you're upset, make mashed potatoes using your hands. Release angry, salty tears and work out your upper body at the same time! Exercise helps with feelings. Something about hormones and endorphins. Same with crying.

Cocktail

Something strong, yet unassuming. Subtle, yet alluring. Seemingly sensible, yet deceptively intoxicating. Like an Adios Motherfucker.

Ingredients

* one overworked and under-aware father
* one unfulfilled, budget-free housewife
* one child vying for affection
* one child vying for approval
* one child vying for the keys to the Mercedes

* potatoes
* butter
* milk
* sour cream
* chives

Instructions

Seek shelter from passive-aggressive dinner table jabs by feigning a head-ache. Retire to your chambers to create an inner fortress of solitude fortified by the empty wine bottles from the family vineyard. Then go on Tumblr to talk to people who really know you for you.

Life Lesson
Nobody has a perfect family.

No matter how great things look on the outside, it's what you can't see that counts. But hey, that doesn't mean that they are all bad either. Nothing is black and white. There may be the day and the night, but not without the dawn and the dusk.

THE DINNER YOU COOK WHEN YOU TELL YOUR PARENTS THAT YOU WANT TO BE AN ARTIST

So you want to be an artist. Well, personally, I think that is magnificent. The world needs people who are brave enough to put themselves out there for public criticism. Oh. You want to do modern art? I thought you were talking about being an "artist" like "painting the future of America through the minds of educated youth" (meaning teaching) or "sculpting a better solution to the current hunger crises in the States" (meaning econonomism*) or better yet "studying medicine" (studying medicine). Because what better art is there than the art of the human body. I mean anatomy is really something, right? Something . . . gross. You can see that this all stems from the same vein. The vein that you have to tell your parents that you are going to follow your dreams no matter how much they spent on your education back when you were following their dreams for them. If this is the case, then go for it. However, if these aren't the cards that you've been playing with, well, then maybe you should stick it out for a couple more years. Just in case being a freelance hat maker doesn't quite pan out the way you'd hoped it would. Having that degree might be a decent backup.

*GOTCHA–SIKE–THAT'S NOT A WORD.

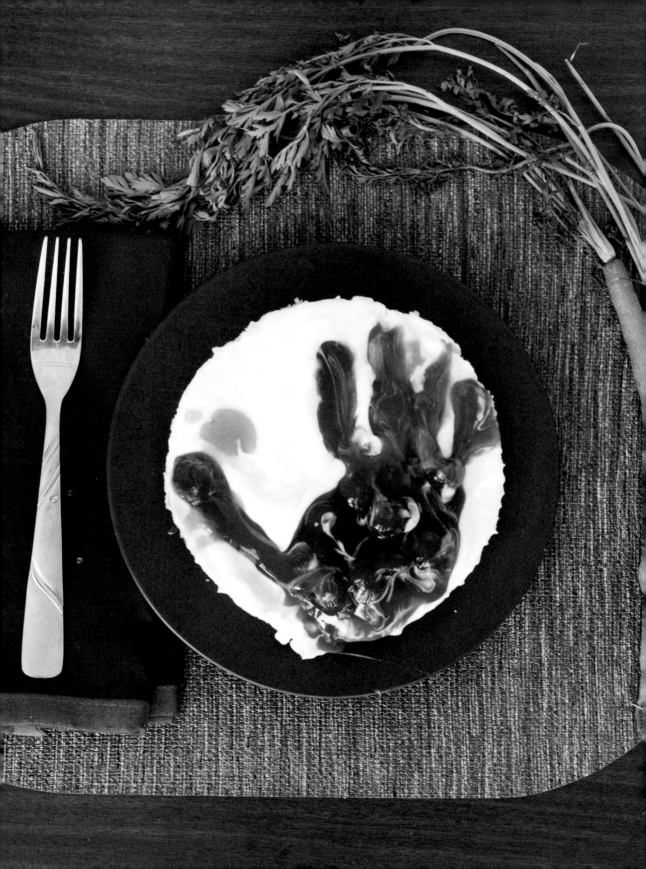

{ THANKSGIVING PIE }

I like football. . . . It's a great way to avoid conversation with your family at Thanksgiving.

—CRAIG FERGUSON

Thanksgiving takes a lot out of you and sometimes you just want to stick your face inside a cheesecake. But instead you decide to use your hand because you don't really want to get cheesecake in your hair. And maybe you did that last year, but you were kind of out of it . . . so you justified it by turning it into a "recipe" instead of just a "negative attention-getting device."

Cocktail

Sparkling cider . . . that you poured vodka into.

Ingredients

* one fully baked store-bought cheesecake
* one can of cherry pie filling
* holiday-related baggage that is manifesting in this weird way right now

Instructions

First and foremost, accept that the holidays suck. Or at least they do in my opinion. I feel like the holiday season is that time of year where you get to-

gether with people you only see 10 percent of the time, but you're supposed to go and be together for this holiday thing. I accept that this might just be my opinion though. But Thanksgiving is great. It's the best a holiday can be! Sitting around and eating and being grateful for all that you've got . . . do it year-round!

Anyway, this year for Thanksgiving don't bottle up all of your holiday-centric angst for an inappropriate outburst before/after/during the meal—try this instead!

- Close your eyes.
- Take a deep breath.
- Put your hand on top of the cheesecake.
- Release your breath and . . .
- Press down.

And then pour cherry goop inside the hand shape and serve! You can use a little caramel syrup to give the turkey a wattle and cartoon it up a bit. Maybe even add some legs and write a little "Happy Thanksgiving!" on the top. Now it looks kind of cute. And people won't think twice about whether you washed your hand first.

Life Lesson

Wash your hands first.
Clean plate. Clean slate.

⬅ ⬅ ⬅

WHAT DO EARTHQUAKES SERVE DINNER ON?

TECTONIC PLATES!

HOW TO COME OUT IN THE GAYEST WAY POSSIBLE

* * * * * * * * * * * * *

RAINBOW CAKE SERVED WITH SKITTLES VODKA

(Note: For those of you currently questioning your sexuality or currently in the closet because you just
don't know what to do . . . I just want you to know . . . it gets butter.)

* * * * * * * * * * * * *

Coming out is a little bit the worst.

Actually, it's a lot a bit the worst. But it's also a lot a bit the best because you're about to enter the rest of your life knowing that while things might not be easy, at the very least things will finally be *honest*.

Also, coming out happens in stages. Not just *on* stages, like musicals.

Stage 1: Coming out to yourself. This means you can no longer ignore the fact that you love the way your best friend smells or how pretty she looks in the sun or how one time she cuddled you while she was asleep and it was kind of the most terrifying moment of your life.

Stage 2: Coming out to your friends and family. This means you can no longer hide the fact that you're madly in love for the first time in your life and you feel so young and alive and free and you want them to be happy for you and you never meant to disappoint them and you're not exactly sure what it all means but you know that you've never felt so whole before like maybe your life is actually real.

Stage 3: Coming out to your coworkers. This means that you are going to very quickly find out who had a crush on you all along and oops, sorry Brad, but we're really just friends! Also, you have a better stapler.

Stage 4: Coming out to every person every time in every conversation. This means that for the rest of your life when people ask you if you have a boyfriend you get to say, "Nope! Also: gay." You'll get used to it, and it's not that big a deal after the first couple times.

Stage 5: Coming out to God. Don't worry. He knew all along.

But just in case any of the above groups are totally in denial about your homo-status, here are some recipes that will help get the point across:

{SKITTLES VODKA}

Depending on how much you want to make, buy some Skittles (or any colored candy-coated delight) and separate them according to gender. I mean, color. Oops. Haha. Can't possibly confuse colors with genders. That would be like saying boys can't like pink things. I know a lot of boys who like some very pink things. NOT THAT PERVERT. I'm talking about meats cooked rare. GREAT NOW EVEN THAT SOUNDS DIRTY.

Step 1: Separate colors.

Step 2: Put them in vodka.

Step 3: Wait.

Step 4: Serve and make it sound like a more complicated process than it was.

* * * * * * * * * *

{RAINBOW CAKE}

INGREDIENTS

* boxed cake mix
* whatever the box says you also need
* food coloring (It occurs to me now that you don't need Skittles to make different colors of vodka. Maybe the Skittles might make it taste sweeter though, so there's that. Just saying it's up to you. Penny-pinch where you'd like.)

INSTRUCTIONS

Make the cake mix and pour it into different tiny bowls. Add food coloring to bowls. Grease a mason jar. Then layer by layer pour each of the colors into the jar. Like a rainbow. Get it? Super gay.

Now put your lovin' in the oven and bake it.

AS SOON AS YOU TAKE THE JARS OUT PUT THE LIDS ON! This will create a vacuum and keep the lid on super tight. It makes a fun popping sound when the seal is formed. Now you can safely mail this to your brother in Afghanistan with a note saying: "YOU WERE RIGHT ALL ALONG! JUST TOLD MOM AND DAD! LOVE YOU!"

YOU WERE
RIGHT!
love ya
XOXO

{ OLIVE-STUFFED BRIE }

Happiness is having a large,
loving, caring, close-knit family
in another city.

—GEORGE BURNS

Forgot you had relatives coming over and promised that you would host? Do this in a pinch so that your visiting family will stop having to pay for everything.

Because really . . . you can handle this?

Cocktail

Chardoonay (Wouldn't that be an adorable way to pronounce Chardonnay?)

Ingredients

* extended family in town visiting
* any and all olives you can find
* a wedge of Brie that you were planning on eating later, but this will do for now

Have some Brie and don't know what to serve it with? Too lazy to make a bread bowl? Well, now you have options!

Ways to Make Hosting a Brie-ze!

- meat sticks!
- other cheeses!
- crackers!
- Legos!
- fingers! (Your own. But now you're just eating it and there won't be much for anyone else . . . oh well!)

Instructions

Step 1: Don't forget that your grandmother (and matriarch of the family) hates olives.

Step 2: Backpedal.

Step 3: Order Chinese.

Spending time with members of your "extended family" can be real hit or miss.

And frankly, relationships change the older you get. Especially if you used to hang out all the time when you were a kid, but then, after your parents got divorced, you never really saw them or kept in touch.

Until now! And it's good to have a good relationship with them because they seem like good people and you're a good people so then it should be easy and worry-free, right?

Well, despite the fact that you're all trying to build bonds . . . it's a little awkward. Nothing is worse than feeling like an outsider in a room full of people you're trying to let in.

Sometimes I can't really tell if I'm the olive or the Brie.

Well, I hope that any of this was even remotely helpful. Discussing family stuff is hard. That's probably why this is the shortest part of the whole book.

Now, if you were triggered early on and skimmed the recipes . . . here is what you missed:

- **Stir Fries**
 (Your siblings aren't gonna be just like you. And that's okay.)
- **Pattycake**
 (After a certain point, you need to just let things go.)
- **Trifle Troubles**
 (Your spouse needs support too! Don't sweat the small stuff.)
- **Pansteak**
 (Edible is more important than seasonal.)
- **Macaroni . . . Pretzel . . . Hand?**
 (Cooking with kids!)

- **Let's Get Grilled**
 (Father figured.)
- **Enmeshed Potatoes**
 (Family means getting space and sometimes smashing things.)
- **Thanksgiving Pie**
 (Wash your hands before ruining dessert.)
- **Olive-Stuffed Brie**
 (Extended family wants to be your friend. No pressure though!)

Basically your family is where it all begins—the root of *all* that is you. The roux in which you bubbled. The marinade that saturated your soul. But that doesn't mean their flavor will come through! It may have coated you to the core, but after some time and various applications of heat or pressure you could come out tasting totally different. You're adding your own spices now! It's up to you what kind of flavors you're going to let linger on the palate of the planet.

But are you looking for a coping mechanism to deal with the family that doesn't involve copious amounts of secret drinking?

No?

Well, too bad! Because here is one of my favorite facts:

BANANAS ARE GOOD FOR LOWERING ANXIETY!!!

Here's why.

Bananas are kind of like nature's beta-blocker. A beta-blocker prevents adrenaline from latching onto your beta receptors. This keeps your blood pressure lower and keeps your heart at a steady rate, instead of both going into turbo drive when you start to get stressed as a result of feeling anxiety. That's physiology, buddy.

Bananas (or, as I like to call them, WONDER FRUIT) also contain high levels of potassium . . . which is something that everyone likes to talk about but I don't really know why. Maybe it's also an anxiety reducer, because a higher metabolic rate (as occurs under stress) results in a reduction of our potassium levels? . . . Sure. I'm gonna go ahead and say that's a reason too.

WONDER FRUIT also contains vitamin C and several B vitamins (isn't that great?) as well as tryptophan (that thing in turkey and wine that makes you sleepy), and maybe those things add up to also help reduce anxiety.

But what does all this wonderful information mean for YOU?

It means that you can try out these banana-bomb recipes and be less stressed without becoming dependent on alcohol! Yay!

Banana Instant Ice Cream: Freeze a banana and then put it in a blender with milk! Yumm!!

PB&B&J: So cute it will make you feel calm!

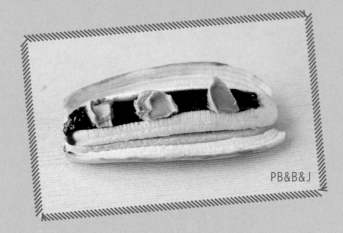

PB&B&J

Bananas Foster Kids: Drink rum and fry bananas while thinking about how our foster care system would be vastly improved by factoring in mental health services for both the children and the caretakers. Then maybe the incentive to provide homes to children would increase because there would be better long-term support in place! Yayy!!! I feel relaxed already!!!

Seriously though, next time you have a big meeting or a performance-type thing, just grab a banana and see how it makes you feel. And who cares if it's just a placebo effect from reading this book? If it works, it works.

You got this, dude.

YOUR

Do you know what the word *harto* means in Spanish? "Satiated." Isn't that so appropriate?

And the more I think about it, the more I like that idea. That your "harto" could feel full and content and maybe a little sleepy, because that's always how I feel at the end of a good meal. Or a good book. And I hope that the time you spent with these pages made you feel a little of both. Full and sleepy.

Now, as you may recall, back in the Introduction I said that the goal of this book was to teach you how to follow your heart by trusting your gut. A lot of you may be saying, "What does that mean? Going with your gut? That's being reckless." But I mean the opposite of being reckless. I mean taking the time to look deep inside (just north of your intestines) and to check in with that feeling you get when you know you're about to make a bad decision. See, our hearts are pretty wishy-washy. They are like:

"Give me feeling! I love Disney!"

"I am a broken equation lost in my own summation."

"I am palpitating because I'm having an anxiety attack but not because you are in actual danger so do your best to ignore me and be cool while I freak out for a little."

Whereas our gut instincts are a little more reliable. I can usually tell if I'm about to do something that directly contradicts my well-being because I get that little shiver of doom in my whole body.

Or maybe that's just when I'm taking a shot?

Look, point is, you know deep inside what's best for you or what you need to work on to get closer to

your truth. You need to trust that your instincts are pointed in the right direction.

Are you going out tonight because you want to?

Are you staying in because you feel trapped?

Do you really need to get coffee with that ex who won't stop calling?

It's okay to take a minute and let your decision sink in before voicing it. If the pit of your stomach is dropping at the thought, then odds are you might have to do a different thing. Maybe not the immediate thing. Maybe not the easy thing. But hopefully the real thing.

For instance, this book may have been hard to do . . . but it was the *write* thing to do!

No?

Okay.

Anyway, they say save the best for last, but I think I gave up the best first because this conclusion certainly isn't going anywhere. I guess I just really want to say thanks?

Thanks for bearing with me, and thanks for reading these thoughts and words. *My Drunk Kitchen* was the best mistake I've ever made and it's allowed me to live a life so wonderful I think I'm in a daydream. I hope that anything printed here helps you get closer to living in yours. Or maybe helps you realize that you're already there.

LOVE,

Hannah

ACKNOWLE

This book could not have been possible without the encouragement of the following people:

First, I would like to thank the teachers who changed my life. Liz Londry, Glenn Morgan, and Alan Tansman, thank you for the years of faith and focus, despite my best attempts to leave all tasks incomplete.

Second, I would like to thank my employers and colleagues who believed I was responsible, despite my best attempts to convince otherwise.

Third, I would like to recognize the people who donated their time (and sometimes even money!) to a fledgling HARTO, INC. before it even became itself. Without such support I would not have been able to couch-surf my way through the Internet waves.

Fourth, I would like to recognize every Hartosexual, and thank them for their excellent taste in comedy and charity. Special shout-out to my Melbourne, LA, Vancouver, and Portland peeps for their continued volunteer efforts!

DGMENTS

Fifth, I would like to thank my editors and design team for their immeasurable contributions to this book and patience with my flagrant lack of commitment to deadlines.

Sixth, I would like to give special thanks to my family of friends who have given me so much (in alphabetical order!): Aunts, Brandon, Emlyn, Erica, Gavin, Grace, Greens, Hannah, Hannibal, Jackie, Justin, Mamrie, Matt, Molly, Morgan, Pearl, Rachel, Sarah, Seth, and Susan.

Seventh, I would like to thank my parents for life and all the lessons within it.

And last, I would like to thank my saviors and my champion: my sisters and my soup.

(But seriously, most of all, I thank my constant costar and companion trapped-no-longer, Cheese. Together we aim to please.)

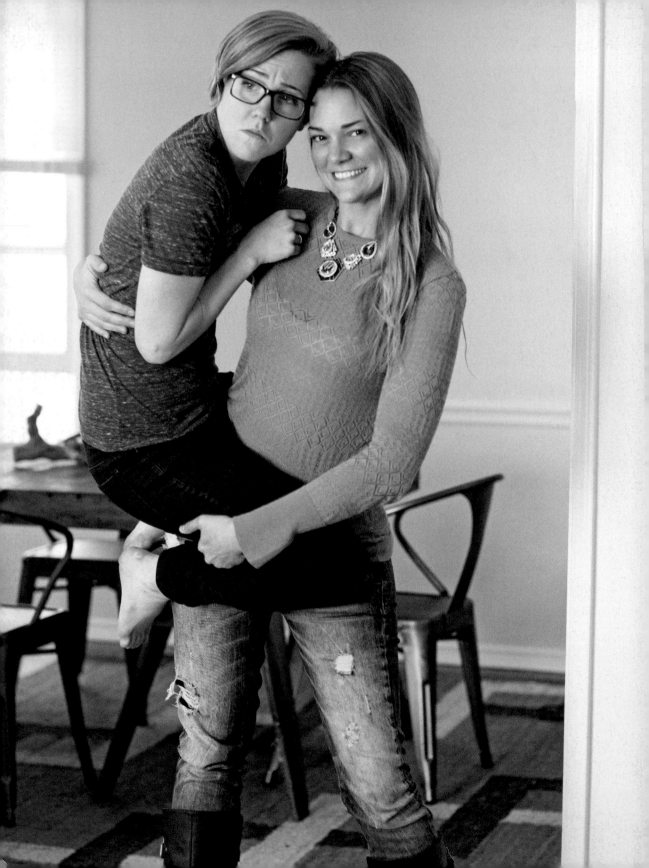

A special acknowledgment needs to be made to honor my photographer and friend, Robin Roemer. Thanks for tolerating the huge mess that this cookbook made and thanks for helping me do all those dishes after. Your wonder is beyond compare. I know I can count on you always being there to pick me up.

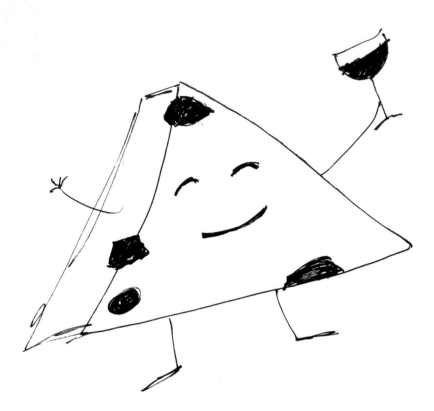

THANKS FOR
READING!

Swiss you
already!

FOLLOW YOUR HEART
BY TRUSTING YOUR GUT...